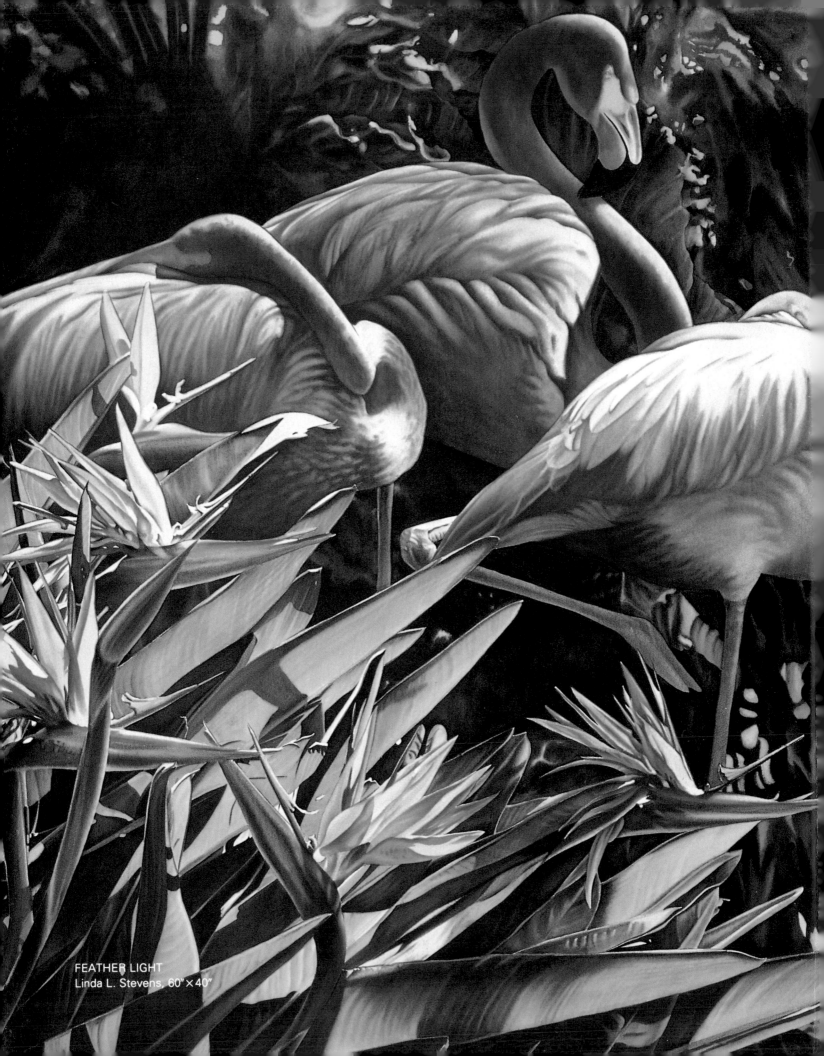

FEATHER LIGHT
Linda L. Stevens, 60" × 40"

Make Your
Watercolors
Look
Professional

Carole Katchen

NORTH LIGHT BOOKS

Cincinnati, Ohio

ABOUT THE AUTHOR

Photo by: Marty Ollstein

Carole Katchen has received numerous awards from national art organizations in her thirty years as a professional artist. Her paintings have been exhibited in galleries and museums throughout the United States and in South America. They have been featured in publications on several continents. She exhibits regularly with Saks Galleries, Denver, CO; American Legacy Gallery, Kansas City, MO; Hensley's Gallery of the Southwest, Taos, NM; and Taylor's Contemporanea Fine Arts Gallery, Hot Springs, AR. She lives in Los Angeles.

Over one million copies of her books have been sold. *Make Your Watercolors Look Professional* is her 14th published book. Others published by North Light Books are *Painting With Passion, Creative Painting With Pastel* and *Dramatize Your Paintings With Tonal Value.* Her articles have been published in many art and general interest magazines including *Southwest Art, American Artist, Cosmopolitan,* and *Parent's.* She is a Contributing Editor to *The Artist's Magazine.*

Make Your Watercolors Look Professional. Copyright © 1995 by Carole Katchen. Printed and bound in China. All rights reserved. No part of this book may be reproduced in any form or by any electronic or mechanical means including information storage and retrieval systems without permission in writing from the publisher, except by a reviewer, who may quote brief passages in a review. Published by North Light Books, an imprint of F&W Publications, Inc., 1507 Dana Avenue, Cincinnati, Ohio 45207. 1-800-289-0963. First edition.

99 98 97 96 95 5 4 3 2 1

Library of Congress Cataloging in Publication Data

Katchen, Carole
 Make your watercolors look professional / by Carole Katchen.—1st ed.
 p. cm.
 Includes index.
 ISBN 0-89134-591-4
 1. Watercolor painting—Technique. I. Title.
ND2420.K38 1995
751.42'2—dc20 95-2413
 CIP

Edited by Kathy Kipp
Cover and interior design by Brian Roeth

The permissions on page 135 constitute an extension of this copyright page.

This book is dedicated to Mike Ward, Mary Magnus, Marty Munson and all my friends at The Artist's Magazine *who have given me the opportunity to enrich my knowledge of art and the art world.*

ACKNOWLEDGMENTS

Special thanks to all the artists who contributed their art and knowledge to this book. And to the editors and designers at North Light Books who put it all together—Rachel Wolf, Kathy Kipp, Anne Hevener, Katie Carroll and Brian Roeth.

METRIC CONVERSION CHART

TO CONVERT	TO	MULTIPLY BY
Inches	Centimeters	2.54
Centimeters	Inches	0.4
Feet	Centimeters	30.5
Centimeters	Feet	0.03
Yards	Meters	0.9
Meters	Yards	1.1
Sq. Inches	Sq. Centimeters	6.45
Sq. Centimeters	Sq. Inches	0.16
Sq. Feet	Sq. Meters	0.09
Sq. Meters	Sq. Feet	10.8
Sq. Yards	Sq. Meters	0.8
Sq. Meters	Sq. Yards	1.2
Pounds	Kilograms	0.45
Kilograms	Pounds	2.2
Ounces	Grams	28.4
Grams	Ounces	0.04

TABLE OF CONTENTS

CHAPTER ONE
Making Peace With Your Materials

Professional artists consider their materials to be partners in the creation of their paintings. Find out from sixteen master watercolorists what materials they use and why.

Demonstrations: The Pros Show You How To. . .
Meet the Challenge of Smooth Paper—*Catherine Anderson*
Use Masking to Preserve White Paper—*Robert Reynolds*
Use Large, Loose Strokes—*Martha Mans*

CHAPTER TWO
Mastering Technique

Discover a variety of watercolor techniques—some with "tricks" and some without—that professionals use to achieve masterful effects.

Demonstrations: The Pros Show You How To. . .
Paint Directly—*William Condit*
Use Salt, Spray and Opaque Washes—*Sharon Hults*
Create Unusual Edges With Masking Tape—*Carol Surface*
Create Soft and Hard Edges—*Eric Wiegardt*
Use Opaque and Transparent Watercolor—*Douglas Osa*

CHAPTER THREE
Laying Down a Structure

Learn how to pre-plan the basic structure of a painting to ensure the final result exhibits vivid contrast, interesting and harmonious shapes, and the hand of a confident artist.

Demonstrations: The Pros Show You How To. . .
Simplify and Harmonize Shapes—*Dale Laitinen*
Look and Plan—*Martha Mans*
Put the Puzzle Together—*Penny Stewart*

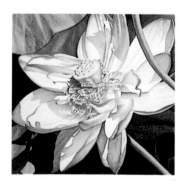

CHAPTER FOUR
Seeing the Light

Create dramatic light, depth and atmosphere in your watercolors with a successful arrangement of lights and darks.

Demonstrations: The Pros Show You How To. . .
Capture the Perfect Light—*Leonard Mizerek*
Create Light with Layers—*Linda L. Stevens*

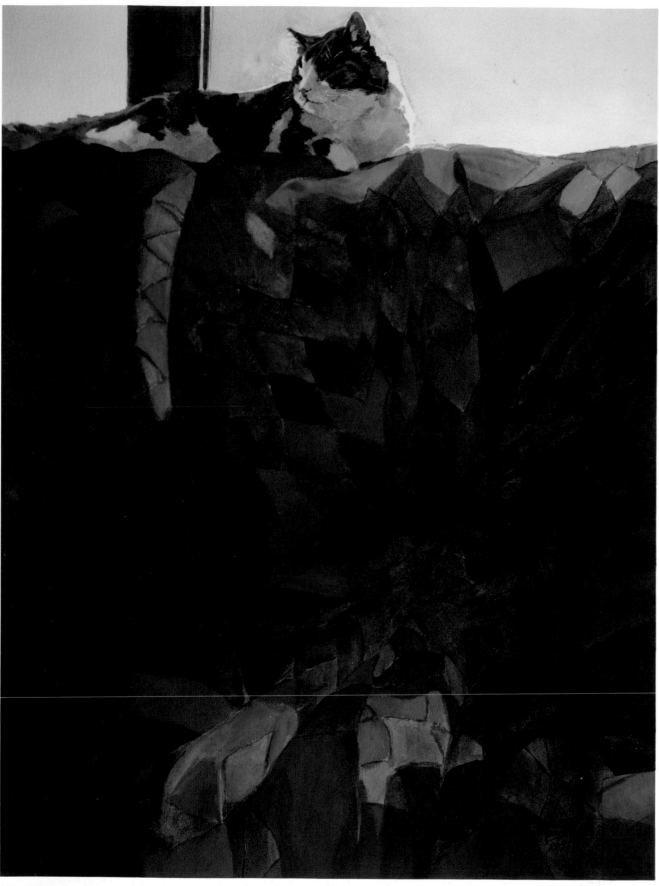

MORNING LIGHT
Martha Mans, 30″×22″

As many amateur artists learn—to their dismay—just putting a price tag on a painting is not enough to make it look professional. There are definite characteristics of "professional" art that have nothing to do with selling or not selling. This book will define what those characteristics are and how to achieve them in your own work.

What are the qualities that make a painting "professional"?

• It has *visual impact*.

Regardless of the individual components, the total image catches and holds the attention of the viewer. The painting conveys authority—the feeling that this artist was the only person who could create this particular picture.

• It has *focus*.

This means there is not only a focal point in the composition, but some element of the painting is most important. It can be color, value, design, a particular technique or the subject.

• It has both *balance* and *contrast*.

Using color, value and composition, the artist establishes enough balance so that the image is harmonious, but also enough contrast so that the painting is not boring.

• It shows *control*.

The artist knows his or her materials. Yes, there are surprises, accidents and mistakes—this is, after all, watercolor. But the "professional" artist sees those accidents as another tool for creativity. Spontaneity is possible because the artist has preplanned the basic structure of the painting.

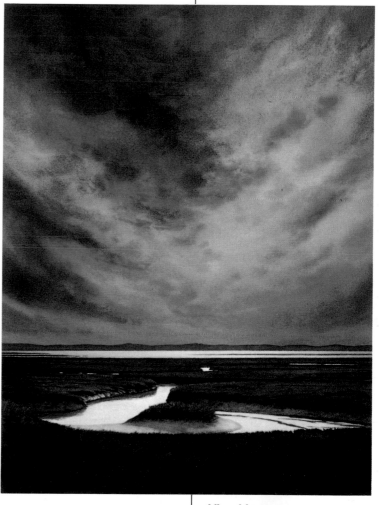

Visual Impact

One component of professional-looking paintings is visual impact. By using strong value contrast and richness of color, Reynolds creates the drama of a breathtaking sunset.

ESTUARY
Robert Reynolds, 37″ × 27½″
Courtesy of New Masters
Gallery, Carmel, California

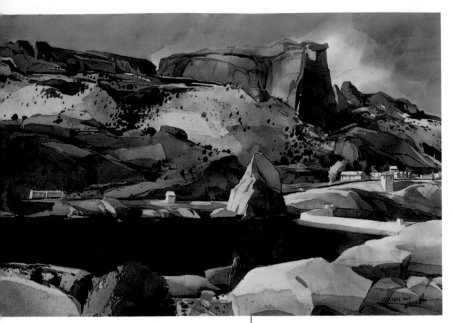

For this book I interviewed a group of successful professional artists who have mastered watercolor. I invited them to share their knowledge of painting in general and watercolor in particular. And although each artist is unique in style and technique, they all point to these same qualities that identify a watercolor painting as professional. What is more, they pass along their insights and advice about how any artist can achieve a higher degree of professionalism in his or her own work.

This book divides watercolor painting into its basic components—materials, technique, design, value, color, subject and mood—and it shows the reader a professional approach

Fearless Use of Color
Any subject can look profes-
sional if it is painted with assur-
ance. Notice the bold division of
shapes and fearless use of color
in this landscape.

RIVER TOWN
Dale Laitinen, 24″×38″
Collection of Don and Alice
Hamblin

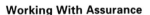

Working With Assurance
Control of watercolor doesn't
mean stiffness. To create this
floral composition, Wiegardt al-
lowed paint to run freely in wet
areas of the paper. Then he
worked with those ''happy acci-
dents'' to develop the final im-
age.

COSMOS 3
Eric Wiegardt, 18″×14″
Collection of Colleen Rinkel

for achieving mastery in each of those areas.

No matter what your level of expertise, this book will help you create paintings that look more professional. For the beginner it provides inspiration in approaching a new medium. It shows that a professional level of competence can be achieved by anyone who is willing to learn the basic principles and techniques. For intermediate painters, this book gives the information needed to move on to the next level. For the advanced painter, the watercolorist who already is a professional, this book passes on the "secrets" of other watercolor masters.

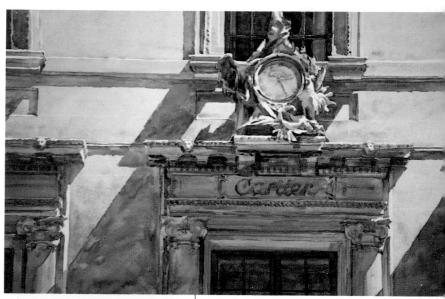

Personal Vision
One indication of professionalism is a personal vision. Here Dalio has taken an architectural subject and added his own imaginative sense of color to give it a new reality.

AFTERNOON SHADOWS—
FIFTH AVENUE
Carl Dalio, 19″ × 28″
Collection of the artist

Interesting Shapes
In abstract paintings it is especially important to fully develop shape and color in a strong and interesting way.

DAY BREAK
Carol Surface, 15″ × 11″
Collection of Susan Henry

Making Peace With Your Materials

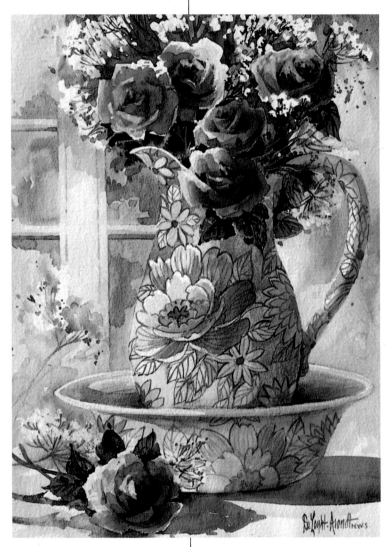

Paper Whiteness

DeLoyht-Arendt likes Lanaquarelle paper because it is very white, but she says all artists must try many different materials to find those that work best for them. Her paints of choice are Schmincke.

HEIRLOOM
Mary DeLoyht-Arendt, 21" × 14"

With watercolor, more than any other painting medium, the artist must be in harmony with the materials. A master watercolorist thinks of the materials as partners in creating the painting. The word *partner* is used deliberately. A partner is someone who works with you to further your goals, and that's how an artist sees his or her materials.

Each variable in the application of paint adds a new direction or characteristic the artist can use in developing his or her own vision. Artists speak of "happy accidents," those moments when the paint does something totally unexpected. They relish those happenings as opportunities to create something new and unpredictable.

For less experienced and less confident artists, however, watercolor may be less of a partner and more of an obstacle. They often dread the tendency of watercolor to do what it wants to do rather than what they want.

With oils or acrylics you can stumble along and your materials will forgive your mistakes. Not so with watercolors. They have a mind of their own and what they do demands attention. Every stroke has a telling effect on the final image. If you don't know what you're doing, the paints will take over, and if you fight with them, they will always win.

How do you get from the frustration of the beginner to the confidence of the professional?

The key is experience, practicing with your materials. Eventually you will know your materials so well that no matter what twists and turns the pigment takes, you are still in control of the final outcome.

How do you gain that knowledge? Paint. It's all there is to do. Dip the brush

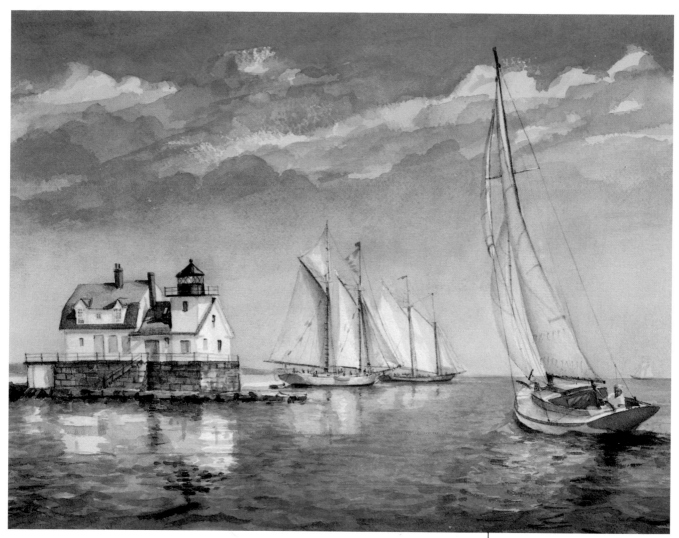

Different Strokes
Different brushes are used for different types of strokes in Mizerek's paintings. A 2-inch sabeline creates smooth, flat washes. A no. 7 round makes beautiful, reflective water strokes. A no. 3 pointed sable works well for fine detail.

SCHOONER DAYS
Leonard Mizerek, 13″ × 21″

in the paint and run the paint across the paper—over and over and over again. Use more water and less water. Rough paper and smooth paper. Big brushes and little brushes. Paint. Paint. Paint.

What Materials Do the Pros Use To Paint Professional Watercolors?

What types of materials should you use? There is no one type of paper, paint or brush that is "professional." Especially with watercolor, the artist has a vast selection of excellent materials.

How do you know which ones to choose? I always ask two questions:
1. Is this material a high-quality, *permanent* substance?
2. Will this material help me *convey the image* that I want to create?

How Permanent is "Permanent"?

The permanence of materials is vital to professionals. I remember buying a beautiful watercolor study of a golden sunset over a loch in Scotland. It was one of my first gallery purchases and I was thrilled to take it home and hang it in my living room. About a year later I decided to reframe it. When I removed the mat, I found that the area behind the mat still showed the exciting yellows

TIPS FROM THE PROS
- Master watercolorists think of their materials as their partners in creating paintings.
- Artists speak of "happy accidents"—moments when the paint does something totally unexpected. Professionals relish those happenings as opportunities to create something new and unpredictable.

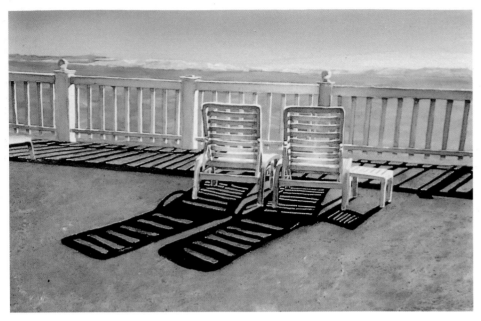

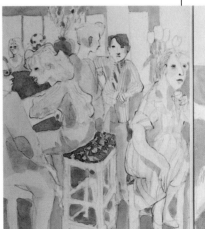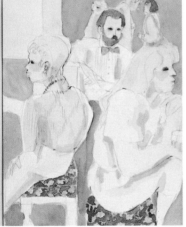

A Toned Surface

For watercolor sketches like this one I love to use softly toned museum board, often the inner, cutout section of mats. The cream color of the mat board here makes a nice base for the skin tones. For brighter whites I use opaque white paint.

REALTORS ON FRIDAY
Carole Katchen, 14″ × 22″

and golds that had first enchanted me; how-ever, all of the painting that had been exposed to light was now a pale, washed-out color. I decided never to buy anything from that artist again.

Even if you are never planning to sell a painting, you still want lasting materials. How frustrating to know that you have cre-ated a beautiful, once-in-a-lifetime image that is going to disappear before your eyes!

Many materials are labeled acid-free or col-orfast to let you know that they are perma-nent. If there is no label, ask a knowledgeable sales clerk or contact the manufacturer. A simple way to test a particular paint or color is to paint a strip of it onto a piece of paper. When it is dry, cover half of it with cardboard and stick it in a window where it is exposed to sunlight. Periodically lift up the cardboard and compare the two sections to see if the color is fading. If it has not faded after several weeks or months, it is safe to assume permanence.

Some colors like Alizarin Crimson are "fugitive" colors. They will always fade in sunlight. If you must use that color, you can extend its life by framing it under ultraviolet-filtering Plexiglas.

Will It Work for Me?

The second question is less easy to answer. The only way I know if a particular paper, brush or paint will work to express my vision is by trying it. I regularly experiment with new papers, brushes, strokes and paints. Besides expanding the number of materials I can use, this experimenting also helps extend my vision. I learn to see in a new way as I try new ways of working.

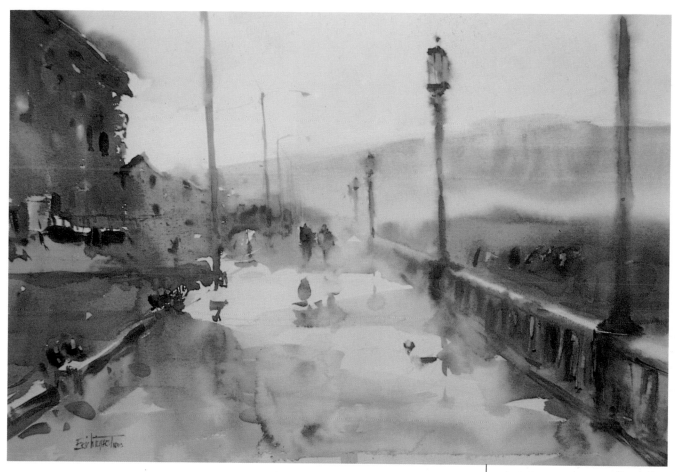

How the Pros Choose Their Paper

Each painting begins with the paper. Watercolor papers vary in weight, smoothness, color and sizing, and each of those characteristics will have a strong effect on the final image that you create.

Interviewing sixteen watercolorists for this book, I found that not only do they use a wide variety of papers, but artists who use the same paper often choose it for different characteristics.

William Condit, who uses a direct painting method with "no scrubbing, scratching or correcting," likes 140-pound cold-pressed Fabriano for its bright white and soft surface.

Mary DeLoyht-Arendt uses 140-pound Lanaquarelle "because it is whiter than Arches and it's very forgiving. You can work with it, lift the paint off and it doesn't break down." She also uses Strathmore watercolor board and Alphamat for a harder surface that allows her to lift up excess color.

Kass Morin Freeman suggests five-ply bristol board, a very smooth surface, for portraits. She explains, "Lights can be lifted out easily and hard edges softened. The color sits on top of the paper and the darks are very intense."

Sharon Hults says, "My favorite paper is 140-pound Arches. I enjoy the texture of the surface and the workability, which allows me to scrub out areas I am unhappy with."

For large paintings Dale Laitinen uses 555-pound Arches Double Elephant. Jennifer Lewis-Takahashi, whose paintings are based on fine rendering of

Soft Paper for Soft Effects

In order to get this soft, flowing effect, Wiegardt likes to use softer, more absorbent papers such as Winsor & Newton, Lana and Waterford. He prefers 300-pound paper so that he doesn't have to take time to stretch it.

SEASIDE PROMENADE
Eric Wiegardt, 22" × 30"

TIPS FROM THE PROS

- Eventually, you will know your materials so well that no matter what twists and turns the pigment takes, you are still in control of the final outcome.
- The permanence of materials is vital to professionals.
- Experimenting with different papers, brushes and paint helps extend your artistic vision. You learn to see in a new way as you try new ways of working.

Paper Texture
Hults uses 140-pound cold-pressed Arches, because she likes the texture and workability, being able to scrub out and re-work areas. Her brushes include a ¾-inch flat; nos. 0, 3, 5 and 8 rounds; and two or three old toothbrushes.

AUTUMN SYMPHONY
Sharon Hults, 30″ × 40″

TIPS FROM THE PROS
- Any good quality paper can be the right paper if it gives you the effects you want to achieve.
- Judges of art shows say that one sure giveaway that a painting is by a beginner is weak, tentative brushstrokes. To look professional, you must be bold in your application of color.
- Think not just of the shape of the subject and the brushstroke, but what's around the brushstroke. That's what makes the painting interesting—the negative space.

detail, uses 300-pound Lanaquarelle cold-pressed. She says she has tried hot-pressed paper, which would give her a smoother surface, but, "It leaves the paint more on the surface. This soaks up the water, but not the pigment. More absorbent papers seem to kill off the color."

Leonard Mizerek says that using a variety of papers makes him "more exploratory." When he uses Arches, it is 140 pound. He explains, "I like the way the color dissolves into it; it doesn't bleed too quickly. The 300 pound, even if it's Arches, soaks up a lot more and blends edges more than I want. Lana hot-pressed is good for light, detailed painting, almost like drybrush."

Douglas Osa uses 300-pound Arches, which he always stretches to keep it flat. When he wants a softer paper, he uses Whatman.

Eric Wiegardt, who paints fairly wet to get the soft, misty look of Washington state, says he also likes softer papers: "Winsor & Newton, Lana and Waterford," he says. "I can manipulate my paintings a little bit more."

I save the insides of acid-free mats to use for small studies. I especially like museum board in light earth tones like cream and off-white. The preexisting color works well for light skin tones. I use darker darks in my painting to make the paper color seem lighter and if I want very bright highlights, I use opaque white.

Any good quality paper can be the right paper if it gives you the effects you want. The only way to know that is to try many different techniques on an assortment of papers. You will eventually find what works best for you.

Paints and Brushes: What the Pros Use

Professional artists use a variety of paints. Jennifer Lewis-Takahashi uses Winsor & Newton, Holbein and Sennelier paints. She says, "My Sennelier paints provide me with my brightest colors."

Martha Mans uses mostly Winsor & Newton, but adds, "Holbein Mineral Violet is more permanent and DaVinci Red Rose Deep takes the place of Alizarin Crimson."

Mary DeLoyht-Arendt says, "I love the Schmincke watercolors. The only time I use another kind is when I can't find the Schmincke. There's no granulation to any of them. Their Cerulean Blue is much more vivid. They have a Brilliant Yellow Light that I use for highlights—it's very opaque, almost white with a touch of yellow. And I love their Purple Violet. It's a beautiful color."

Even within the same brand, characteristics of watercolor paints vary from color to color. There are staining colors, opaque colors and granular colors. Choose the characteristics that work best with your own style of painting.

The same is true of brushes. The artists in this book use flat and round brushes, soft and hard, synthetic and natural, large and small, even old toothbrushes for spattering. The purpose of the brush is to help you express your vision. If you want a big, smooth wash, use a large hake or wash brush. To lift off color, use a hard bristle brush. For fine details, use a tiny pointed brush. Professionals know that brushes are tools and, like masters of any skill, they find the perfect tool for every job.

Making Masterful Brushstrokes

One final word about materials: Art judges know a beginner's painting by its weak, tentative strokes. To look professional, you must be bold in your application of color. You must act confident, even if you don't feel it. Being familiar with your materials makes that easier.

Try every paper, brush and paint that you can find. Then, once you decide which ones work best for you, practice, practice, practice. The more familiar you become with your materials, the more you will be able to feel that the paint is your partner. When it runs in a way you never expected, you will be able to see that as an opportunity, not a frustrating mistake.

Getting Dense Color
This artist uses several brands of paints, Winsor & Newton, Holbein and Sennelier, which she says give her the brightest colors. Even in such detailed paintings, she uses nothing smaller than a no. 4 brush with a sharp point. She says that smaller brushes don't hold enough paint to get the required density of color.

MUSIC & MIRRORS I
Jennifer Lewis-Takahashi,
28" × 35"

MEET THE CHALLENGE OF SMOOTH PAPER

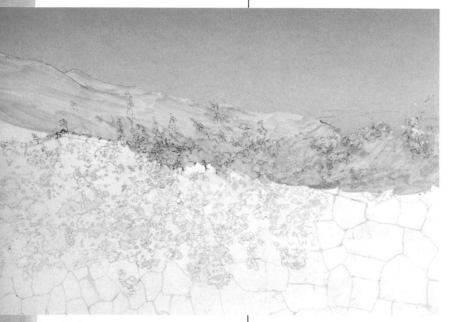

1 ▲ *Anderson begins with a fairly specific drawing on 300-pound Lana hot-pressed paper. Her first washes are the sky color. She uses a wide 3-inch brush that gives her smooth coverage, but not much control of edges. So she protects anything that borders the sky area with masking fluid.*

Catherine Anderson likes to put texture only in the sections of a painting where it will enhance the composition, not over the entire surface of a pebbly paper. So her paper of choice is 300-pound Lana hot-pressed, a totally smooth surface.

Besides the lack of texture, this paper has other characteristics Anderson enjoys. "The watercolors seem to move so beautifully on the smooth surface. The water rolls and the color forms little pools as it dries, which suits my work because I'm becoming more of an impressionist. The color seems to stay truer. And the paper holds the water well. It's totally smooth no matter how many washes I put on."

Layering Smooth Washes

The smoothness of washes is an essential part of Anderson's paintings. In a typical blue sky she might use fifteen or more washes in a variety of colors; for gray fog she has layered more than fifty washes. The blue sky will be primarily blue washes, but she includes other primary colors as well, always repeating colors from one part of the painting in the rest for color harmony. She says this process of layering creates a greater depth in her painting.

In order to get solid, flat washes, she masks out everything surrounding the wash area and she paints quickly with a 5¾-inch hake brush. A good wash brush is crucial. It must hold a lot of water and cover a wide area.

Creating Texture on a Smooth Surface

Since she doesn't have any texture on her surface, Anderson has to create her textures from scratch. She often uses masking fluid as a resist to create texture. For instance, for the stone wall in "Bougainvillea," she first blocked out everything around the wall. Then she masked out the wall and when the mask was dry, rubbed it off unevenly. As she rubbed off the mask, she looked for shapes that looked like rocks and left the mask on in those sections. Then she painted

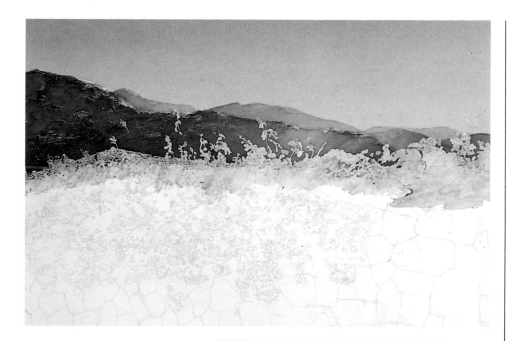

2 ◄ *She removes the mask from the mountains and applies new masking fluid to the top of the bougainvillea. She paints in the mountains, creating texture with layers of irregular strokes.*

a wash of brown over the entire wall area. When it was dry, she removed the remaining mask. She repeated the whole process several times until the wall had a natural-looking rock texture.

Another way she creates texture is by painting with a "funny brush." This is a plastic tube with plastic strips coming out of it, like a tight mop. She says, "It's great for trees and bushes and things like that. But you have to be careful not to overuse it. If you use it too much, it gets a little boring-looking."

Another brush she uses

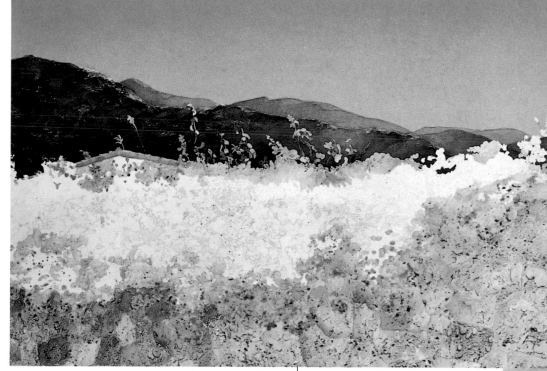

regularly is a no. 10 or no. 12 round. "It keeps me looser," she explains. "I don't want to worry about each stroke, and I want it to look effortless. For scrubbing, I use a white bristle oil painting brush, the harder the better. The 300-pound paper can take it."

3 ▲ *Ready now to paint the foreground, she reapplies masking fluid to the rock area, peels it off unevenly and paints that area. She repeats the process to build up organic-looking textures.*

Planning the Composition

In planning her paintings, Anderson thinks first about the feeling—the mood or atmosphere—and then the composition. She says the most important part of the composition is the focal point. She wants one strong subject in the painting that will pull the viewer's eye in immediately. It can be an object or

4 ▸ *She further develops the rock area, intensifying color and establishing detail.*

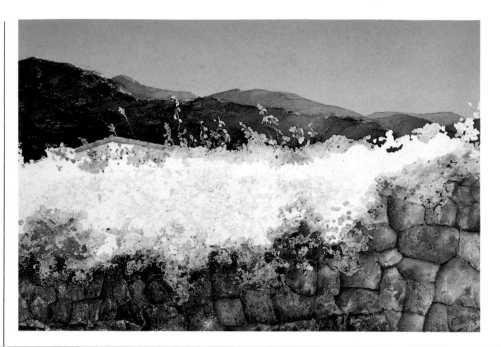

5 ▾ *She removes the previous mask and now adds masking fluid to cover just the white petals and greenery. After the rose color has dried, she removes the final mask. She adds the final greenery and softens unwanted hard edges.*

BOUGAINVILLEA
Catherine Anderson, 22″ × 30″
Collection of Michele Scott

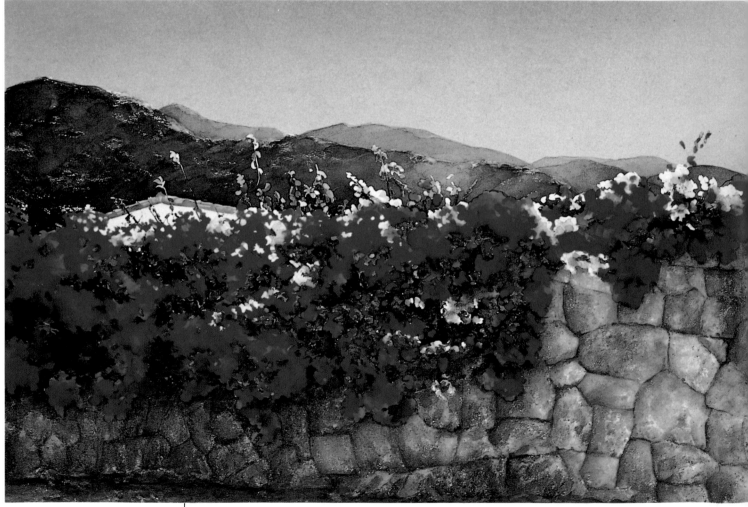

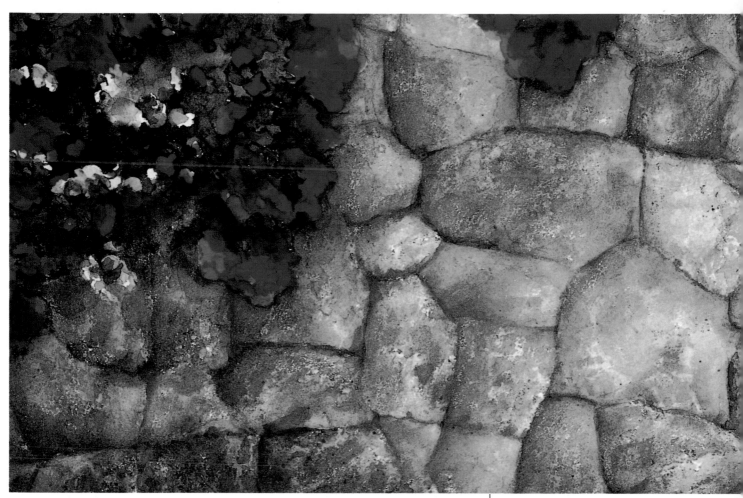

▲ **Detail**
In this close-up you can see the various textures she creates with her techniques of masking, blotting and layering of strokes.

simply the light hitting one section of the scene, which she emphasizes by giving it the strongest light and the strongest color. She places the focal point off-center in accordance with the "golden mean," a principle that will be addressed in chapter three. (See the diagram on page 46.)

Anderson organizes the shapes so they will be balanced, but still interesting. She says, "The whole time I'm painting, I'm thinking not just of the shape and the brushstroke, but what's around the brushstroke. That's what makes the painting interesting, the negative space, like the holes in the trees. If I get in trouble and there's not enough space or light in a tree, I'll go back and create negative shapes with a white bristle brush or a heavy-duty electric eraser."

She has the whole painting planned in her mind before she begins, but allows for some change. She works out the colors as she goes along, testing each new color on a piece of white paper she keeps between her palette and the painting.

Many watercolorists choose the medium for the quickness and immediacy it provides. Not Catherine Anderson. She laughs, "I don't know who in their right mind would do what I'm doing. Sometimes it takes a whole month from start to finish. On a lot of these pieces I save the best parts for last. There is a chance that I'll ruin it at the last minute, but that keeps it exciting."

Robert Reynolds Shows You How To . . .

USE MASKING TO PRESERVE WHITE PAPER

1 ▶ *Reynolds begins this painting with a complex pencil drawing on heavy vellum.*

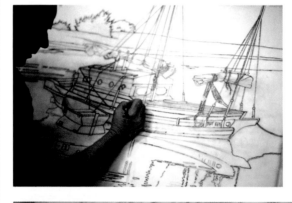

2 ▶ *He transfers his drawing to watercolor paper by rubbing powdered graphite onto the back of the vellum. With a kneaded eraser he removes the excess graphite from the watercolor paper, then sprays the image of the boat very lightly with fixative. He is going to cover the boat with masking fluid and the fixative will keep the mask from removing the drawing. However, he cautions that too much fixative will destroy the surface of your paper.*

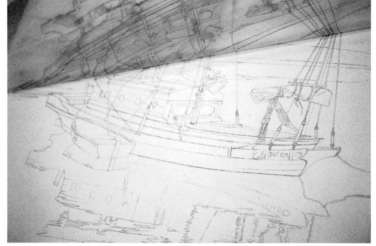

3 ▶ *With the mask in place to preserve the white paper for the boat, he lays in his first light washes.*

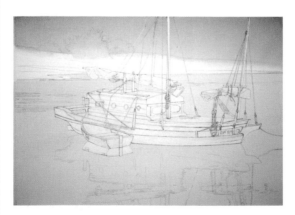

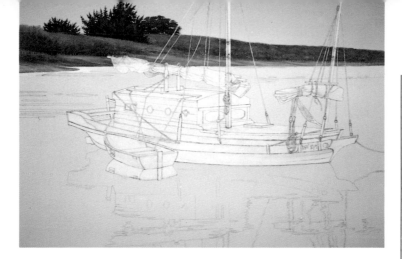

4 ◄ He paints in the darker values of the land. By placing the darkest value (the dark trees) now he provides a gauge for judging the rest of his values.

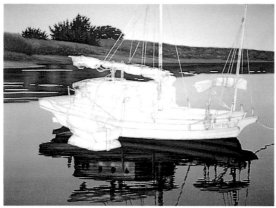

5 ◄ He completes the water and the dark reflection of the boat.

6 ▼ The final step is removing the mask and completing the boat. By using the masking fluid he was able to preserve crisp white paper for the brightest highlights.

MORNING REFLECTIONS
Robert Reynolds, 25″ × 39″
Collection of Dr. Donald Rink

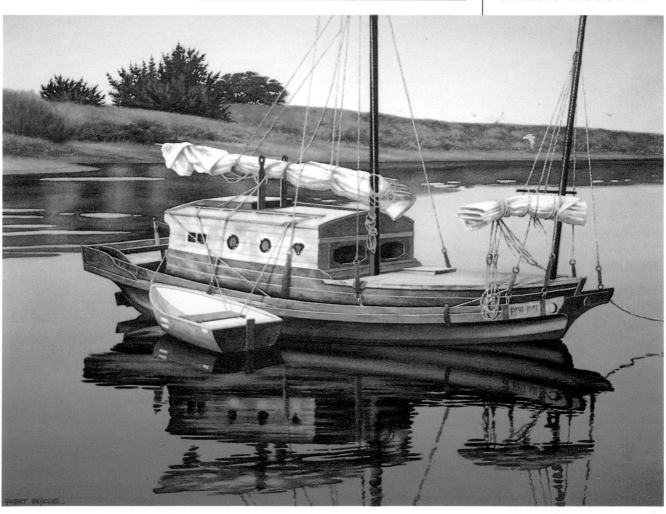

Martha Mans Shows You How To . . .

USE LARGE, LOOSE STROKES

1 ▸ *Mans begins this compo-sition with a pencil sketch on location.*

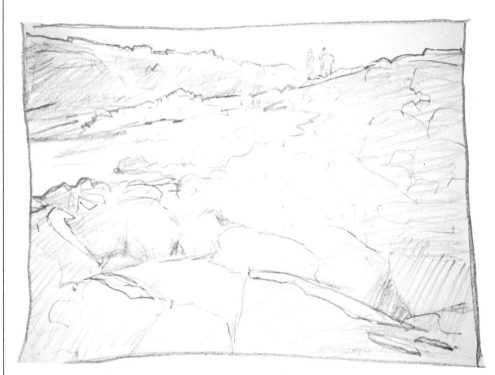

2 ▸ *Referring to photos of the scene, she does a more detailed study in her studio. In these sketches she works out placement of shapes and values.*

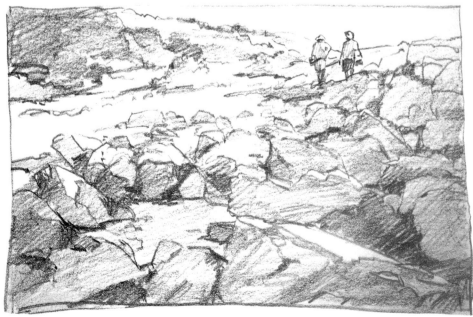

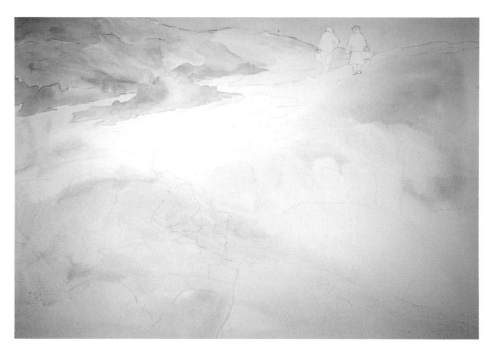

3 ◄ *Over a light pencil sketch on her watercolor paper, Mans lays in her first washes of color. Her paper is 300-pound Arches cold-pressed. This paper is strong enough to hold up under many layers of color and the slightly rough texture of the cold-pressed finish gives an interesting surface texture to the paint. She uses a 1- or 1½-inch flat brush to apply the first loose washes.*

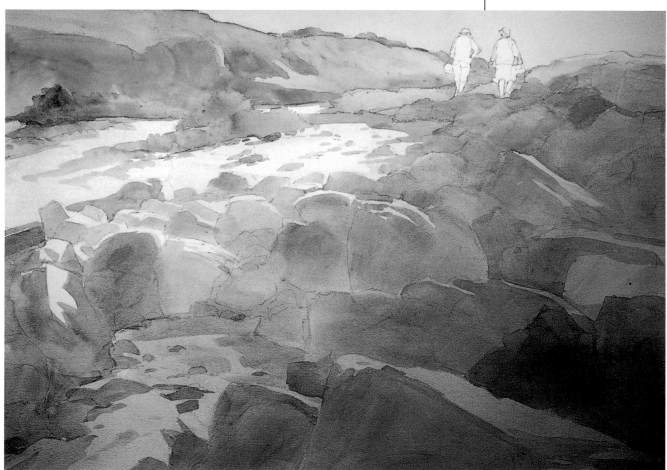

4 ▲ *After drying the painting thoroughly, she continues to use large, loose strokes of the same colors to create the light and shadowed areas of the image.*

5 ▶ *She puts in the darks and begins to indicate detail.*

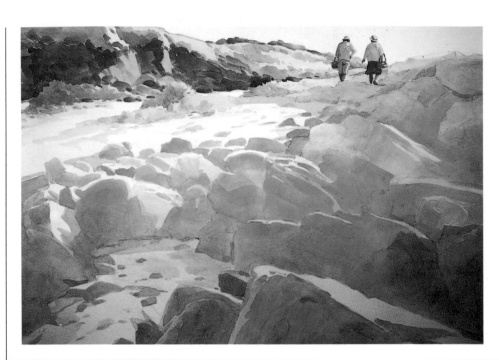

6 ▼ *The last step is placing the final details. Notice that in the finished painting most of the details, such as the shadows and edges of rocks, are created with a medium-sized round brush rather than a small detail brush. This keeps the painting from looking tight and over-worked.*

BEACH STROLL
Martha Mans, 18″ × 24″

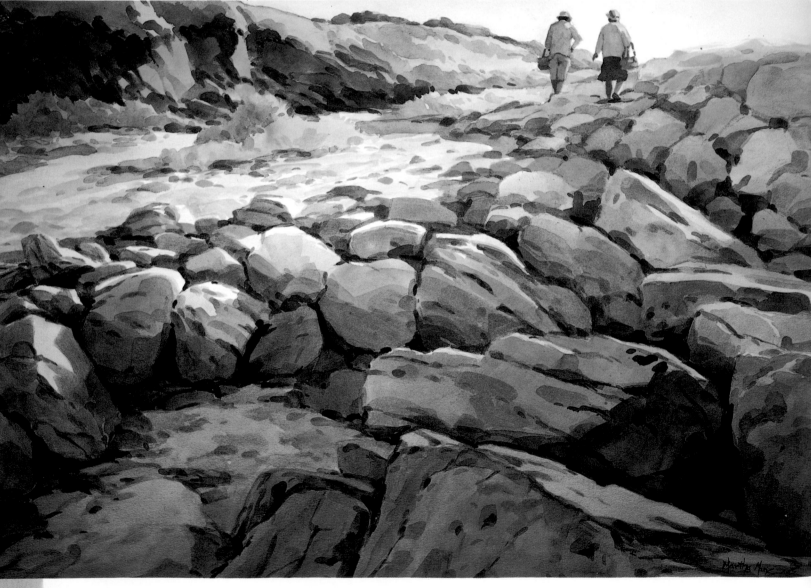

CLOSE-UP OF THE FIGURES

1 ◄ Mans carefully draws the figures to establish both gesture and patterns of light and shadow.

2 ◄ As she lays in the first washes on her painting, she works around the figures, leaving them until she has already established the color and value range of the total composition.

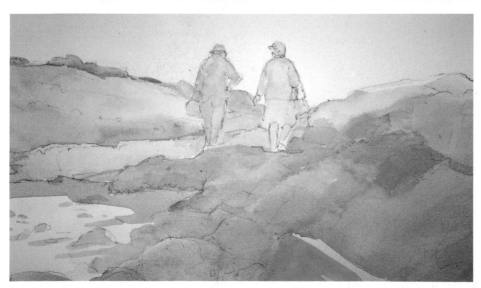

3 ◄ Using the same colors that are in the landscape, she loosely washes in warm, light color on the figures.

4 ▶ *Next she paints in the shadowed side of the figures. . .*

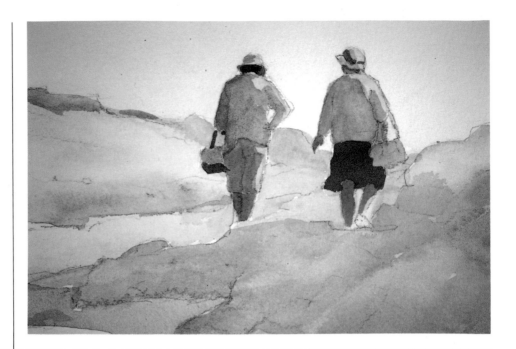

5 ▼ *. . . and adds detail last.*

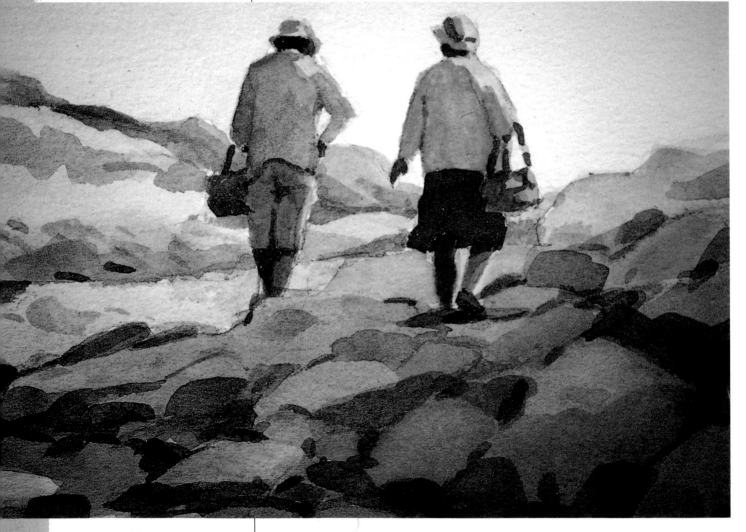

Mastering Technique

Among watercolorists there are two general schools of thought about technique. There are the "purists," who believe that the only acceptable watercolors are those created with traditional strokes of transparent color. They believe that only pure strokes of transparent pigment will convey the beautiful light and color that are the gift of watercolor.

Then there is the "anything-that-works" school. These artists scrub and sponge and cover with opaques, literally doing anything that will help create the mood or image to which they are committed. Carl Dalio explains that point of view: "I don't want to be locked into technique so that I'll approach painting from the technical end rather than from the concept. After seeing paintings by [John Singer] Sargent, who used opaques and created beautiful paintings, I'm not going to be locked into the purity of transparent watercolor. That's what I prefer, but I'll use whatever I have to to get the painting to work."

Neither group is more "professional" than the other. What makes a painting look professional is that the final image has integrity. It looks controlled and well designed, with every stroke adding to the completed effect.

Watercolor is a medium that truly expresses the personality of the artist who uses it, so there are as many different ways to apply the paint as there are artists.

Choosing a Wash Technique

Take the basic technique of the watercolor wash. You can wet the paper where the wash is going to be or you can pull a brush loaded with paint across a dry area. You can mask out shapes within the wash or mask out hard edges around the perimeter. You can lay in one wash that is heavily saturated with color or

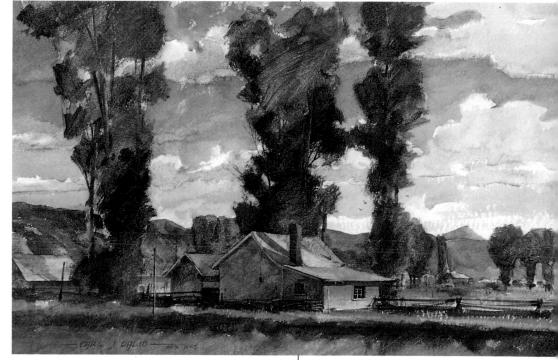

Visible Strokes

Dalio likes an active surface texture, so he loads his brush with paint and uses a variety of bold strokes, even moving the pigment around with his fingers.

AFTERNOON LIGHT—SNAKE RIVER VALLEY
Carl Dalio, 14" × 21"
Collection of Mr. and Mrs. G.L. Martyn

TIPS FROM THE PROS

- What makes a painting look professional is that the final image has integrity. It looks controlled and well designed, with every stroke adding to the completed effect.

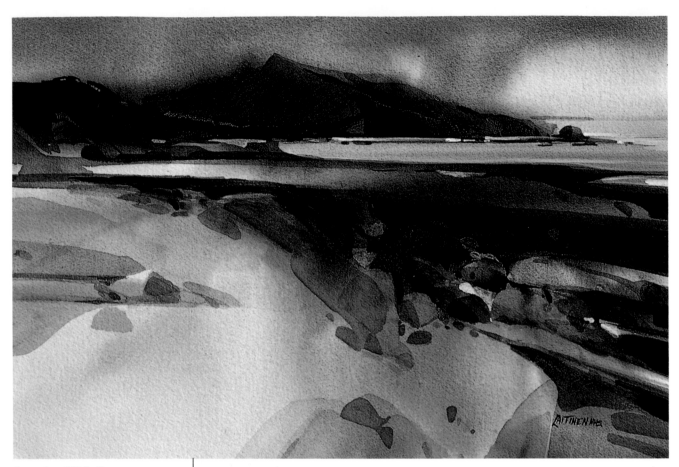

Layering With Gesso

Laitinen often uses gesso as well as transparent watercolors in his layering techniques. In the light blue water area he applied a large shape of gesso. When that was dry, he covered it with a wash of blue. For bright highlights on the water, he applied strokes of gesso to the surface.

LOW TIDE
Dale Laitinen, 15″ × 22″

TIPS FROM THE PROS

- Be fearless in exploring new techniques. As you find the ones that are most appealing to you, keep practicing with those. Eventually they will become as comfortable and unique to you as your own handwriting.
- Professionals never allow "tricks" to become more important than the painting itself. Don't mesmerize the viewer with how clever you are.

you can glaze with a series of light washes. You can drop or charge different colors into your wet wash or create texture by sprinkling in salt or sand.

No one way is The Right Way. What is right for each artist is the stroke or technique that best expresses his or her vision. The best way for the novice to discover what techniques will comprise his or her personal style is to try everything. Experiment. Take classes and workshops. Be fearless in exploring new techniques. As you find the ones that are most appealing to you, keep practicing with those. Eventually they will become as comfortable and unique to you as your own handwriting.

Working on Wet or Dry Paper

One technical decision you make will affect all the others: Should you work on wet or dry paper? Again it depends on what images you want to create. If you want soft, flowing shapes with no hard edges, work wet-into-wet. If you want sharper edges and fine details, paint on a dry surface. For many artists the best solution is a combination of both.

Look at the moody images of Eric Wiegardt. To create his rainy day scenes he works very wet, but he lets sections of the painting dry as he works and he places occasional hard edges and sharp details into those spots.

Working Wet and Dry
The organic textures of the fruit here were achieved by dappling colors onto the surface with a medium round brush. Where more blending was wanted (the oranges), the dots of color were applied to a damp surface. For the specific spots on the strawberries, the surface was completely dry.

BAG OF FRUIT
Carole Katchen, 8″ × 11″

MAN ON BICYCLE
Eric Wiegardt, 22″ × 16″
Collection of Arlene Sparks

The Pros Reveal Some Tricks of the Trade

One of the most seductive elements of watercolor painting is the variety of "tricks" available. Because the pigment is diluted in water, it is very easy to manipulate. Playing with the paint is fun and exciting, but it can be dangerous. Professionals never allow the tricks to become more important than the painting itself.

Robert Reynolds says, "I don't want to mesmerize the viewer with how clever I am. I don't want that to get in the way of the mood I am trying to create or the message I am trying to convey. I learned early that if a little bit of salt looks good, a lot of salt will not necessarily look better."

Here are a few tricks and other techniques that professionals use to enhance their images:

Carl Dalio: "I like visible brushstrokes. I'm looking for another way to get texture, as if I'm painting with pastels or oils. I load the brush with color like impasto in oil. I imply detail with short choppy strokes or long flowing strokes. I get into it with my fingers and move the paint around."

Kass Morin Freeman: To get the textures of weathered paint and metal she spatters paint,

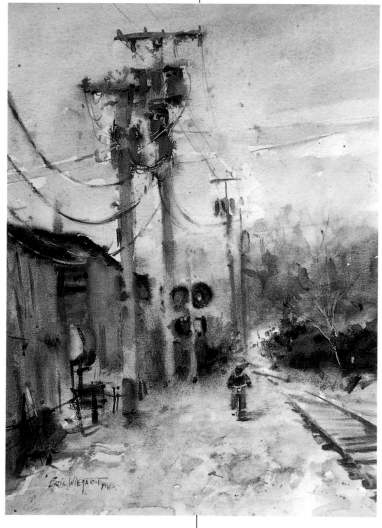

Building Darks with Glazes
Stevens achieves the dramatic, dark values in her paintings by building up numerous layers of glazes. She does little mixing of colors on her palette, but uses the glazing technique to blend colors on the surface of the painting.

THE THIRD DAY
Linda L. Stevens, 31½″ × 60″
Collection of Judy and Mel Grimes

FINGERS
Linda L. Stevens, 29″ × 35″
Collection of Robert Dunlap

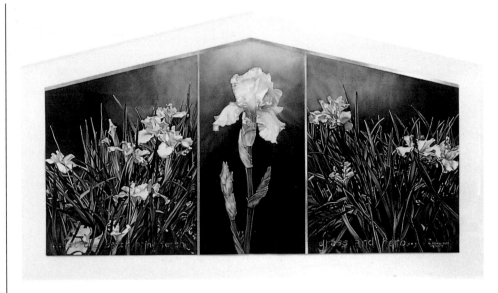

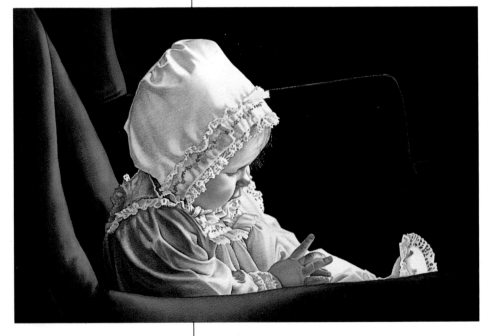

TIPS FROM THE PROS
- Work the whole painting as one piece so it's moving all the time. A common fault of the beginner is to get stuck on a small area of the painting.
- Abstract elements must support the painting. There must be a reason for them being there and they must show continuity of color and design with other elements of the painting.

sprinkles salt, sprays paint on with hair spray bottles, and presses lace and other textured fabrics into paint.

She says, "I use them to solve a particular problem. I am usually very straightforward about technique. When it looks like oil is splattered over a machine, I splatter paint. It's like nutmeg or cinnamon—a little bit goes a long way. When I first discovered the sponge to lift off texture, I used it all over the surface and ruined the painting."

Dale Laitinen: "Arches rough paper creates a texture all its own. To create more texture like speckles in a foreground area, I spray rubbing alcohol or flick my brush. From time to time I use gesso or acrylic or pencils. It stems from my college days when I was encouraged to be experimental.

"I use gesso to create big, simple shapes. I can bring color back over the top when the gesso dries. More and more I have been laying on heavy opaques against translucent passages for increased contrast. The surface takes on an exciting layered quality. Of course, if you use too many, it might not succeed.

"I use two kinds of pencils: Prismacolor wax-based pencils to resist the watercolor, and watercolor pencils to create a more subtle line and color. I can always blend it by putting a little water over it."

Leonard Mizerek: "Occasionally I use salt. I scrape into a wet area for dark lines or scrape into a finished painting for highlights or edges. I scrub out or occasionally use opaques in a limited way.

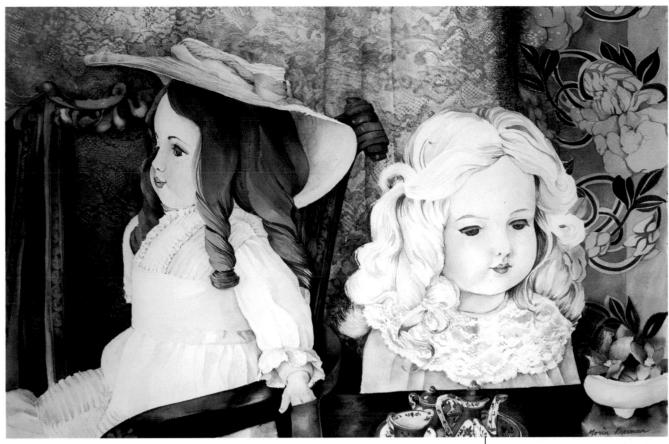

"Also I use mask in between washes. I draw it on with the back of a brush for grassy areas. On a hot day you have to mask in an area that breaks into the sky and lay the wash in fast. You also have to take that masking off fast, especially in the sun. I use a rubber cement pickup, a piece of hard rubber that cleans it up best."

Robert Reynolds: "To make my paintings look more spontaneous I create lost and found edges by going back in with a wet tissue and smearing an area to take it out of focus. Then for contrast I sharpen other edges."

Penny Stewart: Because Stewart prefers a surface with very little absorbency, she applies additional sizing to Arches cold-pressed paper. She says, "It's stiff like gelatin (Winsor & Newton prepared size) so I heat it in the microwave for about fifteen seconds, then paint it on and let it dry.

"The paint sits on the surface and allows me to do two things: 1) easily lift paint to change a shape or color, even after the paint has dried, and 2) create a variety of textural effects. By dropping water or paint into a partially dried area, I can get starburst shapes, run-backs or 'oozles.' Certain pigments seem to repel each other. For example, a mixture of Phthalo Green and Cadmium Red will separate on the paper's surface, creating a mottled appearance in a foliage shape."

Carol Surface: "The techniques are so much fun to use, you just want to do it all over the paper, but it has to look like part of the painting. Never use tricks for the sake of tricks. It's just so obvious. If you can tell what trick I used, I change it.

Lacy Effects

To get the lace texture in the background of this piece, Freeman painted lace fabric and then pressed the wet fabric onto the paper. For the pattern in the lower left she dampened, but did not paint, some lace and pressed that onto the dried, dark blue paint.

TEA PARTY
Kass Morin Freeman, 21" × 28"

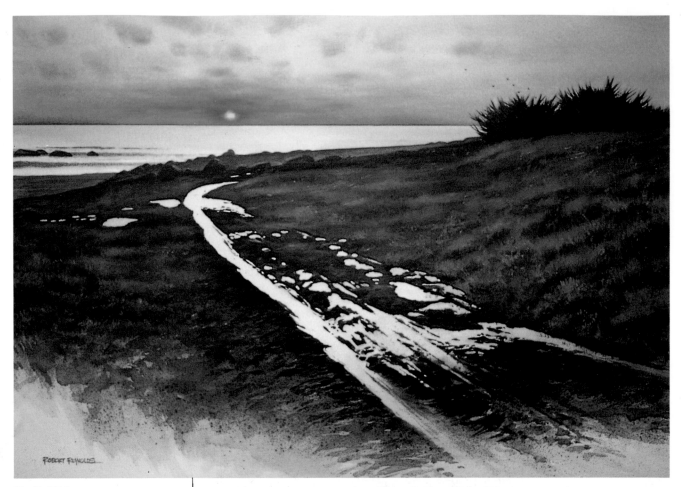

Varied Edges
Reynolds will sometimes use tissue to create lost and found edges.

MOONSTONE BEACH
Robert Reynolds, 26½″×37″
Collection of Mr. and Mrs.
Robert Fishburn

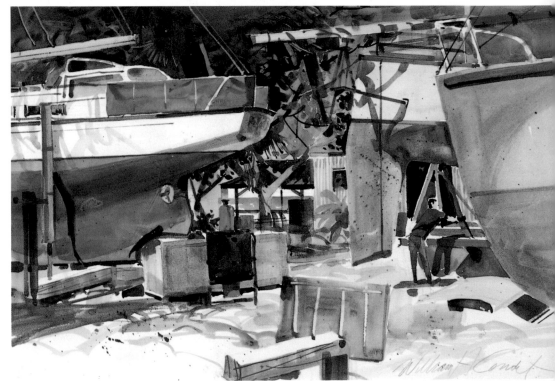

Subtle Scrapes and Spatters
Although Condit generally avoids "tricks," he will occasionally spatter paint or scrape into wet paint for lighter details. Notice how subtly he uses those devices in this painting.

DRY DOCK IN HAWAII
William Condit, 15″×22″

Creating a Harder Surface
For a less absorbent painting surface, Stewart applies extra sizing to her cold-pressed Arches paper. The harder surface allows her to lift up unwanted paint and also to create interesting textures.

LADY IN THE GARDEN
Penny Stewart, 15″ × 22″

"I use them to lead me in a direction, not for surface treatment. They are often just a way to get me going."

Surface often begins a painting by pouring color onto the paper and then manipulating the shapes. She squeezes paint into a plastic cup, adds a few squirts of water until it has the consistency of heavy cream, shakes it up and then pours it on. She turns and tilts the paper. She moves paint with a brush or credit card, presses waxed paper into it for texture or blots it up with a roll of toilet paper.

Douglas Osa: "I go to great lengths to get desired results without using any 'tricks of the trade.' When used sensitively, they are fine, but personally I find them difficult to work into my paintings. Whenever I do use one (masking fluid, for instance) I find that a considerable amount of effort is necessary to rid the painting of the telltale signs it leaves behind."

TIPS FROM THE PROS
- Even if you love the effect of a particular technique, if it doesn't contribute to the success of the total painting, scrub it out or paint over it.
- Keep precut mats and a frame handy so that you can assess your artwork as it would be presented to the public.

Using Salt

Hults achieves the impression of spatial distance by keeping her foreground shapes sharper and more intense and softening the distant forms with salt, sprayed water and opaque glazes.

LONG'S PEAK I
Sharon Hults, 21″ × 28″

WARMED BY THE SUN
Sharon Hults, 22″ × 18″

William Condit Shows You How To...

PAINT DIRECTLY

William Condit is a traditional watercolorist. He likes to paint on location, using transparent watercolor in quick, deliberate strokes. He avoids preliminary studies and paints "to keep," with no reworking of passages. The painting is indistinguishable from the process. If it doesn't work, he throws it out and starts another one.

This is not to say that he doesn't plan his paintings. From the time he first looks at a potential subject, he is analyzing its shapes, colors and values. With decades of experience as a graphic designer, Condit is always concerned about composition. The subject must have a strong focal point and several interesting subordinate shapes as well as lights and darks that can balance in an interesting way.

1 ▲ *After studying the subject for a long time, Condit carefully draws it directly on his watercolor paper with a 2H pencil.*

First . . . Study Your Subject

Perhaps the most important part of his preparation is *looking*—looking at the subject and looking at the blank white paper until he is confident that he has the painting in his head. He knows the placement of shapes, colors and lights and the impact he wants the painting to have.

With a 2H pencil he lightly draws the subject on his watercolor paper. "The quality of the pencil line should be as fine as the quality of the painting itself," says Condit. "I hold the pencil upside down, using my whole arm to draw. I stand back, and avoid touching the paper so I don't get oil from my hand onto the surface."

Second . . . Use Large Strokes for Basic Structure

Then, using a large brush he paints the first third of his painting in one passage. Condit says, "For the first statement I use a large brush full of a lot of paint.

2 ▶ *William Condit is a purist when it comes to transparent watercolor. He believes the color should go on "fast and fresh" with no reworking. He paints on 140-pound Steps cold-pressed paper with large brushes and lots of paint so that each passage can be a complete statement. In between passages he dries the painting with a hair dryer.*

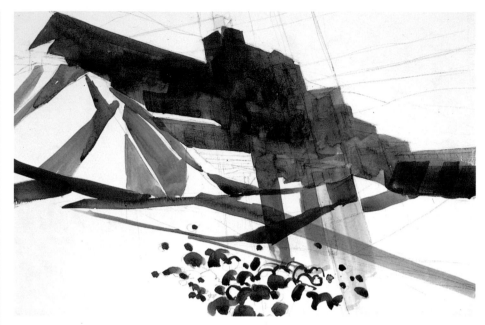

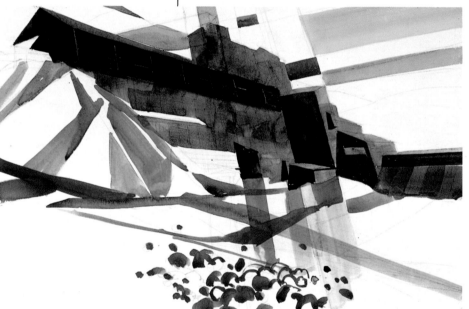

3 ▲

Be sure you load enough water and pigment in the brush for a full passage. I work the whole painting as one piece so that it's moving all the time. A common fault of the beginner is to get stuck on a small area of the painting."

The large strokes may look spontaneous, but they are not haphazard. Before he puts brush to paper for any major stroke, he knows where it's going to begin and where it's going to end.

Once the basic structure of the painting is in place, he lets the painting itself tell him what's needed next. He continues to work with large brushes as long as he can before going down in size for details.

Condit works with the painting vertical on an easel, letting gravity give the paint more movement. He keeps a tissue in his left hand to catch unwanted drips. When the paint gets to where he wants, he dries it with a hair dryer to stop further movement.

Third . . . Use Color for Interest and Detail

One of the most important elements of Condit's painting is color, unexpected colors flowing into each other within a given shape. He explains, "If you paint a whole sky Cerulean Blue, it's dead. You have to paint other colors into that sky. Lay green and purple next to the blue in puddles. Don't mix them together,

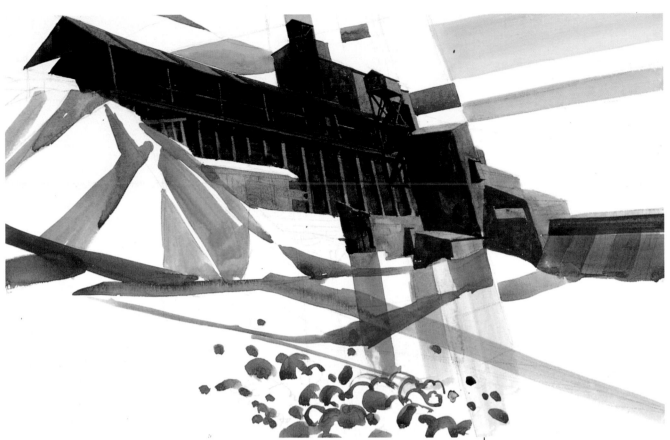

4▲

but pick up the other colors in the brush and drop the new colors into a wet area."

He uses color to eliminate unnecessary detail. He says, "For the side of a barn you don't have to paint every board. Use a lot of color for interest and then *suggest* a slat or board or two."

He combines abstract and representational elements in his paintings, often using an abstract background behind figures. He cautions that abstract elements must support the painting. There must be a reason for them being there and they must show continuity of color and design with the other elements of the painting.

Finally . . . Use Mats and Frames To Assess Your Painting

Between painting sessions, when the painting is dry, Condit turns it upside down to see if it's still balanced and still interesting. He keeps precut mats and a hanging frame handy so he can assess the piece as it would look presented to the public. He warns, "Don't judge your painting all curled up against a tree."

5`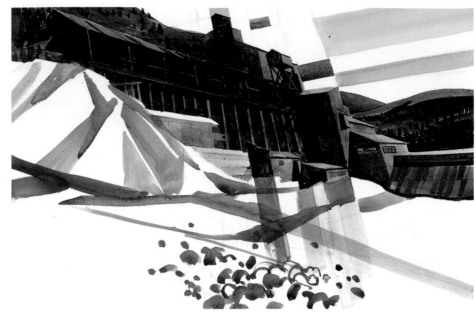

6`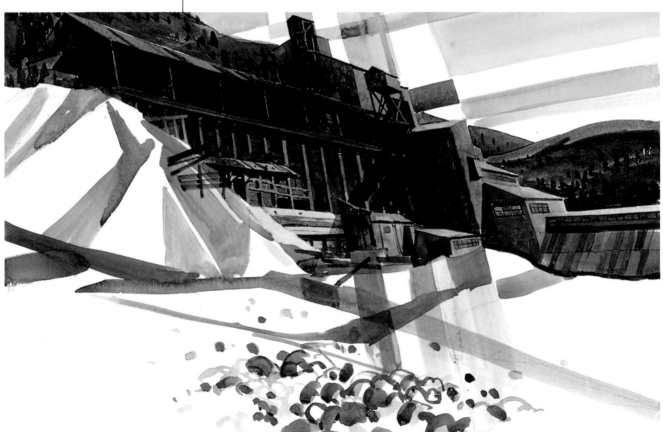

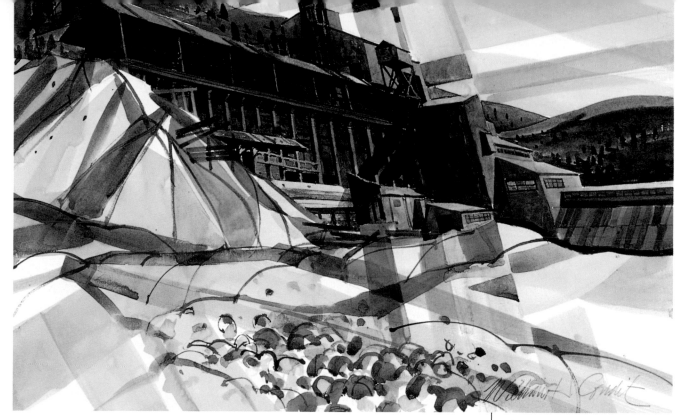

THE ANGLES OF THE ARGO
William Condit, 15″×22″

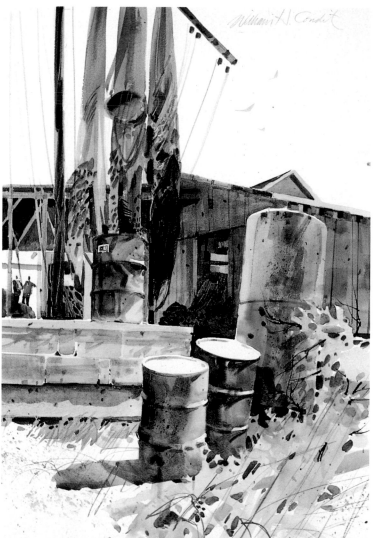

Create Interest With Color Accents

After laying in the large washes of color, Condit went back with a smaller brush to create the small accents that add interest to the surface of the piece. Notice that he arranges them in design patterns to enhance the overall composition.

FLORIDA SHRIMP DOCK
William Condit, 22″×15″

Sharon Hults Shows You How To...

USE SALT, SPRAY AND OPAQUE WASHES

Sharon Hults loves to paint mountains—the majesty of their form, the delicacy of their foliage, the subtlety of their atmosphere. Over the years she has developed watercolor techniques to capture these disparate qualities of mountains.

Softening Edges With a Spray of Water

One of the most important tools in Hults's studio is a spray bottle of water. In order to have maximum control of color placement, she paints about three-fourths of her image with drybrush. That can give too stiff and technical a look to natural scenes. So when the paint has dried, Hults sprays areas of it with water, letting the sprayed water soften the edges and surface of the dried paint.

For foliage areas she often sprays water onto the dry paper with a coarse spray, creating droplets of water with dry paper in between. Then she paints the foliage. Where the paper is dry, the paint forms precise, hard edges. Where the paint runs into droplets of water, it softens.

Another technique for foliage is to spatter color onto the paper with a toothbrush. Then she sprays the edges that she wants softened or more irregular. She can also pull the wet edges with a brush to get a more pleasing shape.

Sprinkling Salt for Subtle Texture

For texture in mountains and foliage she sprinkles salt into a layer of paint. She says, "Your paper needs to have a slight shine from the paint, but you want no puddles standing. The humidity in your studio also affects how the salt works."

For a more subtle texture she repeats the process with several layers of paint and salt, letting each one dry in between. If it begins to look like too much of the texture is showing in the painting, she will glaze over some of it with a wash and no salt.

Photos
Hults begins by assembling photographs for the composition of her painting.

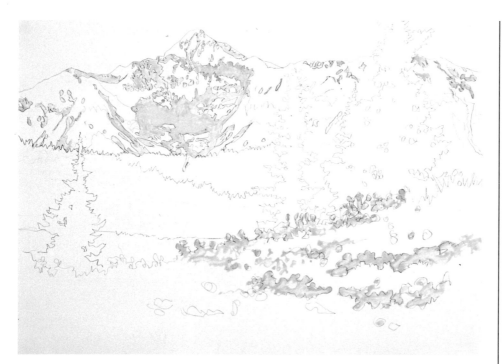

1 ◄ *Hults carefully draws the image in pencil on 140-pound cold-pressed Arches paper. She masks out the areas that will remain lightest.*

She paints with the paper flat and unmounted so she can easily switch back and forth between several paintings. Working on more than one at a time, she is able to let each layer of color dry for two or three days, setting the color and making it impervious to lifting.

Layering With Opaque Glazes

To create atmosphere in her mountains, she often glazes over them with Permanent White Designers' Gouache. She explains, "I often paint my mountains a stronger color than I want because I always glaze over them with at least one opaque layer. You can create several different mountain ranges by adding more layers of the white glaze for greater distance. If you use too much, you can scrub it off like transparent watercolor.

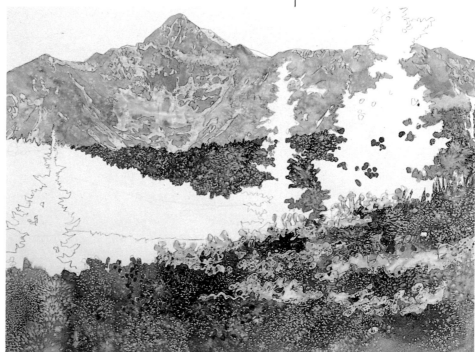

She glazes over most of the large shapes. As she finishes each area, she salts it lightly.

"Sometimes I spray, salt or blot lightly to give an irregular effect. It needs to go on looking like it's almost going to blot out the image because it dries much lighter."

She also mixes color with the opaque so that she can go back and lighten an area or add light details over dark. With the use of opaques, she says she can build up layers and get the irregular effect of nature.

Putting It Together

How does she keep the techniques from overwhelming the image? First, she plans her composition carefully. She combines slides and photos to get exactly

3 ► *While the colors in the mountain peak are drying, she lightly sprays it with water and adds color to the shadowed areas. Again she salts lightly. By continuously spraying and salting she builds up an interesting surface texture. It is very obvious in the first stages, but gets more subtle as she adds more layers.*

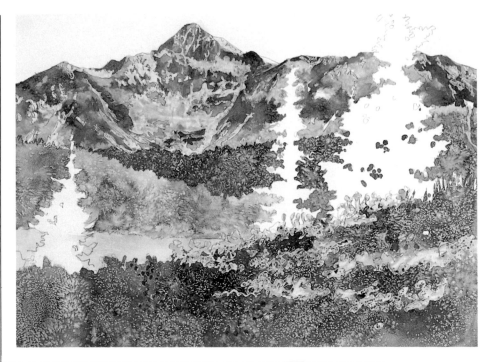

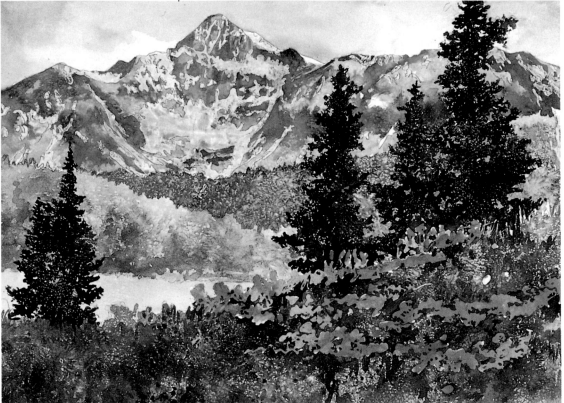

4 ▲ *The irregular effect of the color in trees and grass is achieved by spraying loosely with water. Then she adds color, letting it flow into the puddles of water. Additional texture is created with salt and by spattering with a toothbrush onto the grass area. The mask is removed and flowers are added.*

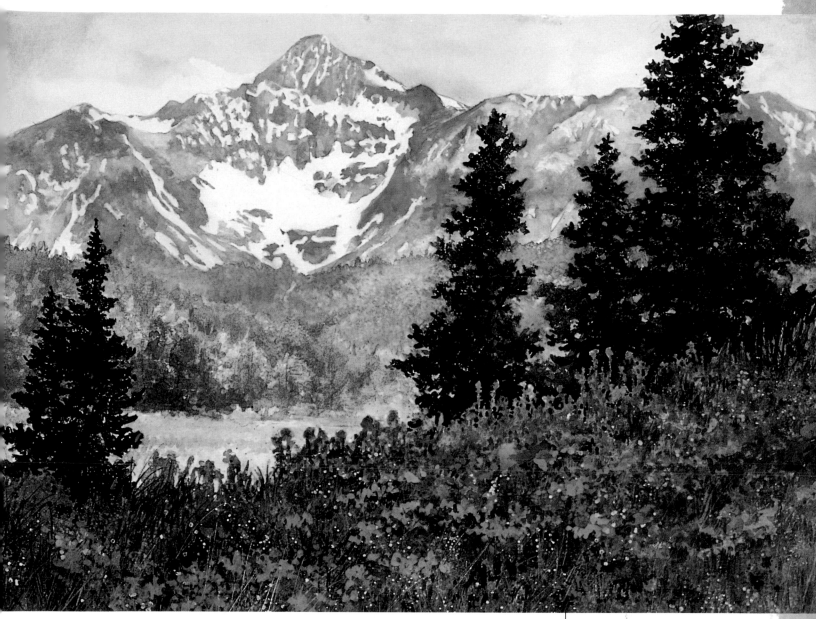

the image she wants and then draws that carefully onto the watercolor paper. The sketch is important for establishing realistic perspective of all the elements (a tree in one photo may be bigger than a mountain in another) and keeping consistency in the highlights and shadows.

As she continues to add color and texture with her various techniques, she keeps looking at the image as a whole. She might love the effect of a particular technique, but if it doesn't contribute to the success of the total painting, she scrubs it out or paints over it.

5 ▲ *Final colors are added and enhanced. Then after everything has dried, a thin glaze of white gouache is added over the mountain and distant hillside. More flowers are spattered into the foreground and opaque grasses are laid in for a finishing touch.*

WILSON PEAK
Sharon Hults, 22" × 30"

Carol Surface Shows You How To . . .

CREATE UNUSUAL EDGES WITH MASKING TAPE

1 ▸ *Surface begins most of her abstract images by pouring paint onto the paper. Here she prepared the paper by brushing clean water onto the paper, skipping a few spots across the center. Next she squirted alcohol across the center of the paper. Then she poured Permanent Rose, Winsor Green and Rowney's Violet Alizarin and tilted the board, letting the colors interact with the water, alcohol and each other.*

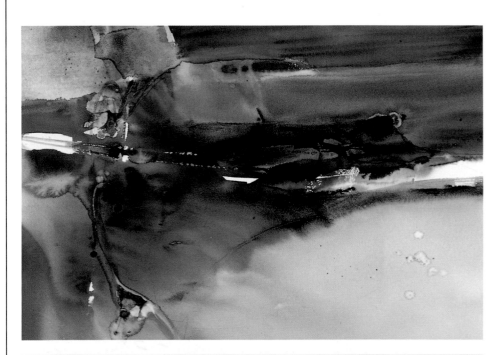

2 ▸ *She created the star-like shape by attaching masking tape and painting dark blue inside the tape. The masking tape holds the shape, but allows paint to leak for a more interesting edge than does masking fluid.*

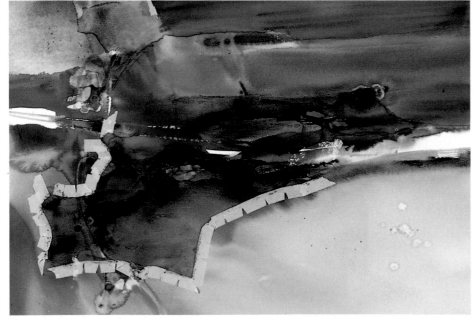

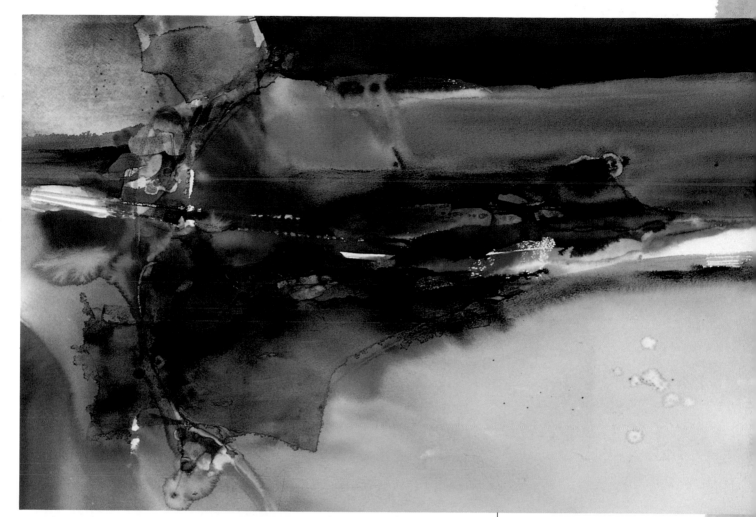

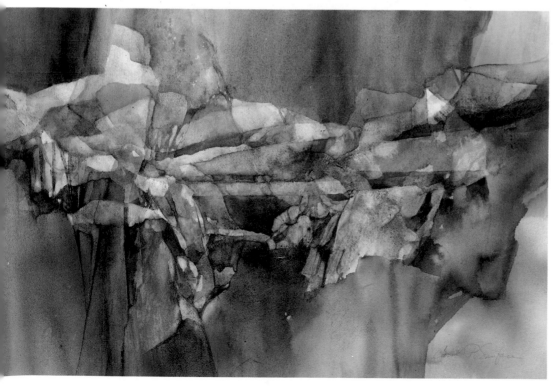

3 ▲ *She balanced the compo-
sition by intensifying some
of the dark shapes in the upper
section of the painting.*

SPIRIT SHIFT
Carol Surface, 22″ × 30″

SENTIMENTAL JOURNEY
Carol Surface, 15″ × 22″
Collection of Ms. Terylann Knee

Eric Wiegardt Shows You How To . . .

CREATE SOFT AND HARD EDGES

1 ▸ *Wiegardt begins with a light, loose wash to indicate shapes and values of the composition.*

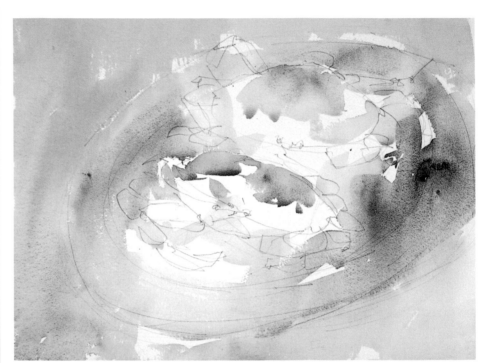

2 ▸ *He loosely blocks in the large shapes and colors.*

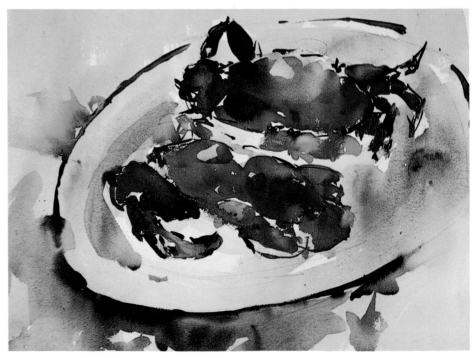

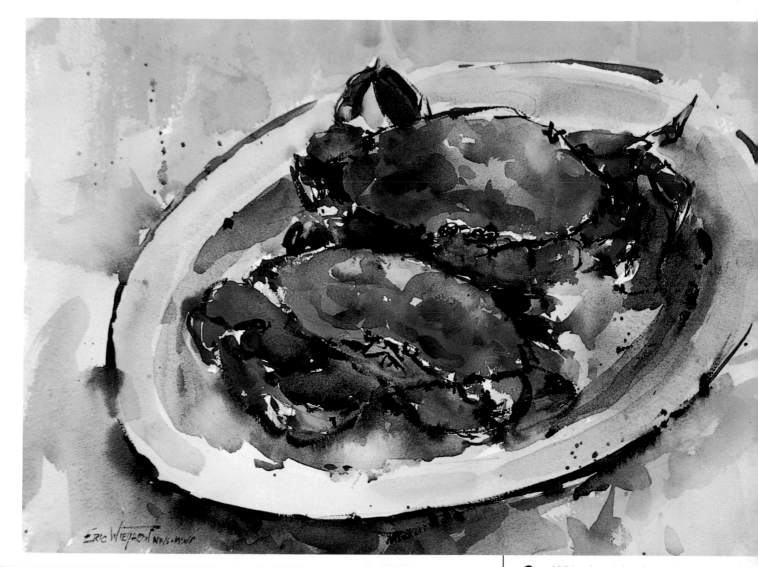

3 ▲ *With a brush he draws in details. By painting on the paper as it is drying, he creates a variety of hard and soft edges.*

DINNER
Eric Wiegardt, 14″×18″
Collection of Lyle & Marilyn
Jane

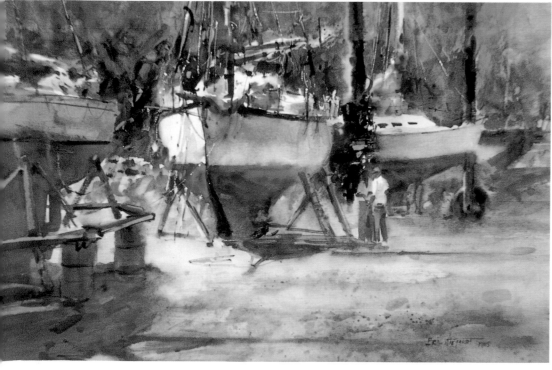

DRYDOCK
Eric Wiegardt, 22″×30″
Collection of Denise Fuentes

Douglas Osa Shows You How To . . .

USE OPAQUE AND TRANSPARENT WATERCOLOR

1 ▶ *Osa began this painting with an old watercolor he had lying around the studio. He scrubbed out the image that he wasn't happy with, leaving just the basic shapes to use as the foundation of a new painting.*

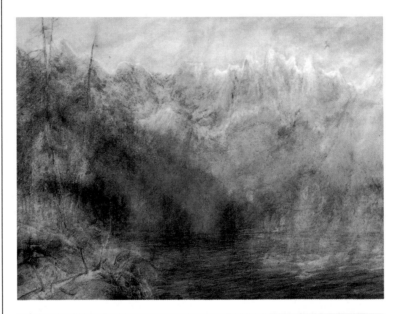

2 ▶ *To recapture the lights, he used opaque gouache, especially on the right side of the scene where the sun was hitting the mountains. For the shadowed left he used dark transparent watercolor.*

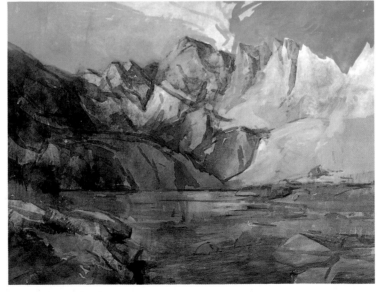

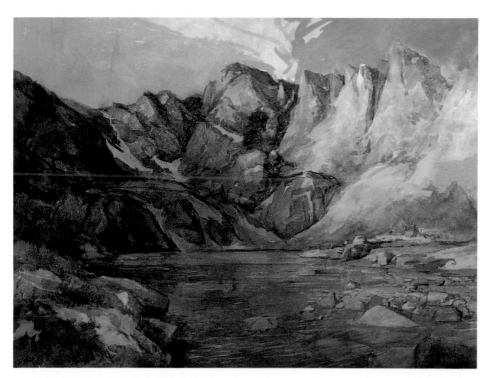

3 ◄ *By this point the masses of color and value are all in place. Osa works back and forth with opaque and transparent color so that the total painting will be unified.*

4 ▼ *The last step is adding detail and smoothing unwanted hard edges. Notice how he blended the passage from sky to cloud.*

SKY POND
Douglas Osa, 18″ × 24″
Courtesy of Hensley Gallery
Southwest, Taos, NM

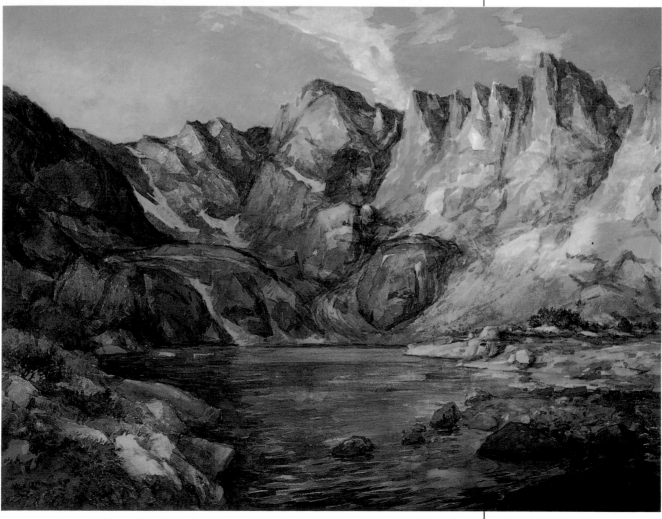

Laying Down a Structure

I ronically, what makes a painting look free and spontaneous is often pre-planning. Especially with watercolor, when the paint is moving fast and with a mind of its own, the artist must have a clear sense of his or her destination. Of course, you can never plan a watercolor painting completely—the pigment is too unpredictable. But you can plan the basic structure, and that can make all the difference between a professional and an amateur-looking painting.

Planning the Whites With a Value Study

A black-and-white study helps the artist simplify a complex scene into basic shapes and also allows for predetermining the value structure of the composition. With watercolor it is especially important to know where the whites are going to be so you can preserve the purity of the paper.

HENDRICK'S HEAD LIGHT
Leonard Mizerek, 19" × 29"

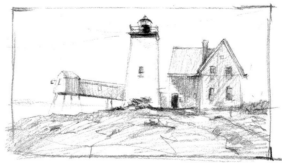

Begin With the Whites

A place to begin is with the whites. It is the contrast between intense colors and the pure white of the paper that gives transparent watercolors much of their punch and if you want those brilliant whites, you must protect them from the beginning. Yes, you can scrub out color and you can add opaques to lighten an area, but that sparkling white of the paper can never be recovered if it is lost.

So, many artists begin by locating the whites. Some artists take the time to work out value studies either in thumbnail or larger sketches. By working first with just black and white, they are able to visualize the relationships between the lightest and the darker areas. When they begin actual paintings, they refer to their studies as guides.

Others simply work out the relationships in their minds. Then they sketch

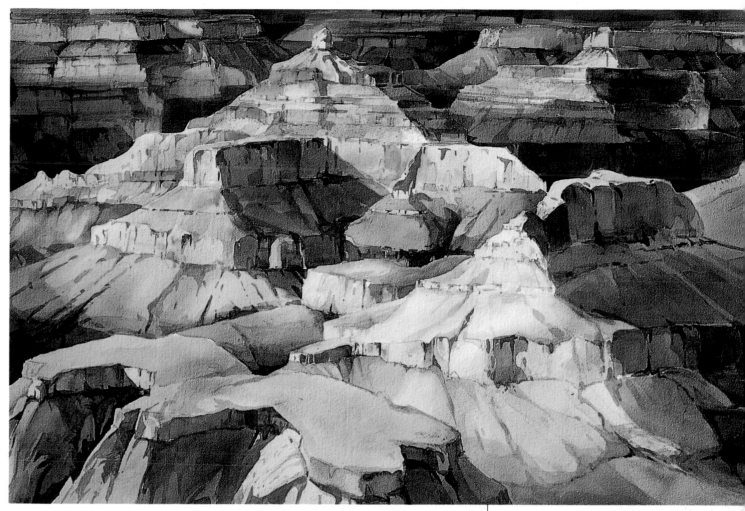

a simple outline onto their watercolor paper in pencil or retain the plan in their minds. To protect the whites, they either block out the white areas with a masking agent, or they paint around them.

Look at Your Subject as Abstract Shapes

How do you know where to put the whites? Look at your subject in terms of abstract shapes. Forget that this is a picture of mountains or a portrait or a bowl of fruit. Look at it just as a group of squares, circles, triangles and other simple forms. The challenge of composition is to make those pure shapes look interesting.

Wherever the light falls, the shapes will be naturally lighter. You can create dramatic contrast by surrounding those light shapes with darker shapes.

Locate the Focal Point

Many artists begin to plan their compositions by locating their focal points. The focal point is an interesting spot in the painting that naturally draws the viewer's eye. Often it is the lightest spot in the piece. Once the focal point is determined, all the other shapes are placed in such a way that they either lead the eye toward or away from that point. Later in this chapter, Dale Laitinen and Martha Mans tell how they control eye movement.

Arranging Abstract Shapes
What makes this piece work is the abstract design of light and dark shapes. Even with such a "real" subject as the Grand Canyon, the professional artist must be able to reduce the scene to its abstract elements.

NOVEMBER LIGHT,
GRAND CANYON
Dale Laitinen, 29½" × 41"
Collection of The Dolese Co.,
Oklahoma City, OK

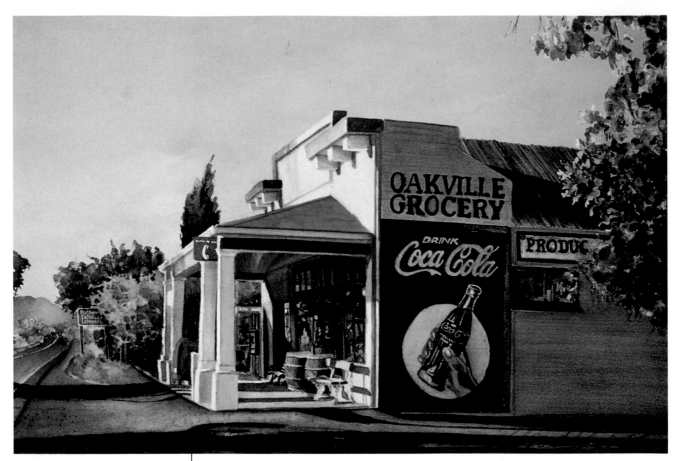

Using the Golden Mean Diagram

Catherine Anderson says one of the most effective ways of placing focal points is by using the principle of the golden mean. Divide your format into thirds horizontally and vertically. The four spots where those lines intersect are optimum locations for a painting's center of interest. In this painting by Anderson you can see that the main focal point, the Coca-Cola advertisement, sits on the lower right point of the diagram.

OAKVILLE GROCERY
Catherine Anderson, 22" × 29"

TIPS FROM THE PROS
- Planning the basic structure can make all the difference between a professional and an amateur-looking painting.
- Look at your subject as just a group of simple forms— squares, circles, triangles—and make those pure shapes look interesting.

Work for Contrast, Balance and Harmony

When you look at the subject as abstract shapes, you can see how all the elements relate to each other: dark against light, large shapes against small, round against angular, smooth against textured, warm against cool, intense color against muted color.

The ideal composition is one where there is enough contrast to keep the viewer looking at it, but also enough balance and harmony among elements so everything sits comfortably on the paper.

If you have trouble seeing the abstract elements of a scene, draw it in black and white, showing only the largest shapes. Or squint at it. Squinting helps eliminate details. One of the greatest challenges for beginners is to get beyond the details to the larger forms. A successful painting rests on the overall structure. No matter how well you paint the details, if the larger composition doesn't work, the painting will not work.

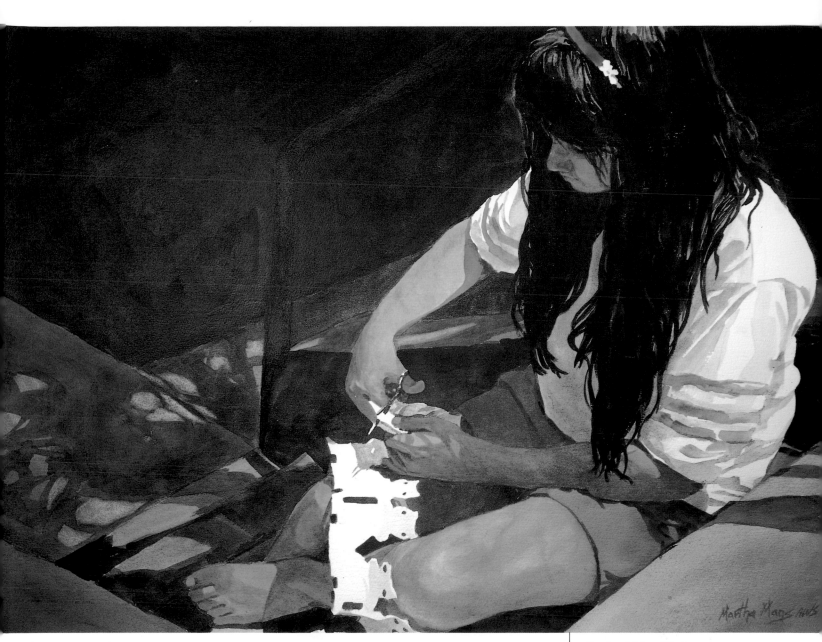

Seeing Value Shapes

What gives this painting its visual impact is the placement of very light values against very dark values. Because Mans feels the values in her paintings are so important, she plans out the values in a black-and-white sketch first, so she is able to preserve the light areas on her watercolor paper.

PAPER CUTOUTS
Martha Mans, 22″ × 30″

Using a Sketchbook
In these pages from DeLoyht-Arendt's sketchbook, you can see how she prepared for Along the Bank. *Before she began the finished watercolor of this Southwestern scene, she thoroughly explored the shapes and colors of Southwestern plants and terrain. When she had several possible compositions, she picked one (third from top) and used that as the basis for the finished painting.*

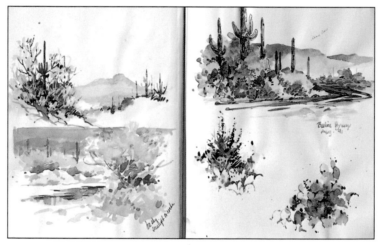

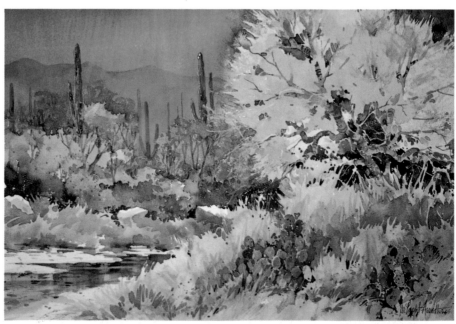

ALONG THE BANK
Mary DeLoyht-Arendt, 14″ × 21″

Planning With Photos

Photography can be a good tool for preplanning a composition. As seen here, Lewis-Takahashi often combines several photographs to get the final image she paints.

STRAW INTO GOLD II
Jennifer Lewis-Takahashi,
27" × 22"
Collection of Dan Ho

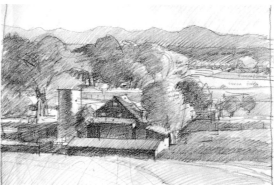

Preparing for Spontaneity With a Pencil Sketch

Dalio is able to be bold and expressive with his strokes and colors because he has already planned out his composition in a preliminary study and notes. He is not a slave to his study, but allows it to guide him in the execution of the watercolor.

COLORADO FRONT RANGE
Carl Dalio, 13½" × 21"
Collection of the artist

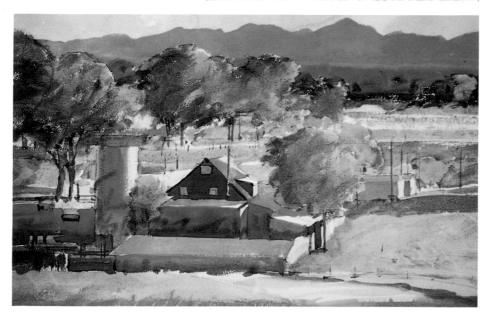

Dale Laitinen Shows You How To...

SIMPLIFY AND HARMONIZE SHAPES

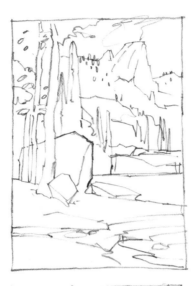

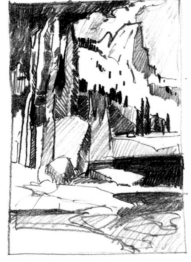

Preliminary Sketches
Laitinen begins his composition with a series of pencil sketches on typing paper. Sketching is his way of formulating the design. The first sketch is "nothing more than a vague representation of a subject, a visual road map in my search for composition," Laitinen says. The second is more refined in shape and composition. The third is a definite plan of value as well as shape.

For as long as I've been painting," says Dale Laitinen, "I've been looking for ways to simplify shapes."

One solution he has found is to separate himself from the subject. When he works on location or directly from photos, he tends to be too literal. He likes to start with an observation or a memory of a scene, turning that into a thumbnail sketch. From that sketch he will refine the design until he comes up with a workable composition.

Sketching the Relationship of Shapes

He explains, "When developing an idea for a painting, I usually do several pencil sketches, beginning with a few lines to indicate general space divisions. As the idea evolves, the subject becomes more specific and space relationships become more sophisticated. At this stage, I try not to think about details or objects, only the relationship of the shapes.

"I use several sheets of cheap typing paper one after another, refining each sketch as the idea progresses. Value sketches arise out of these line drawings and help to solidify pattern and movement in my composition."

He starts with a two-dimensional breakdown of shape, not thinking of the shapes themselves but how to harmonize them. He says, "If I have a large empty shape, next to it I will place small shapes to make it more interesting. If I have all diagonals, I will flatten some of them out or turn them into curves to control the energy. If I have a lot of verticals, I make them shorter, longer, thicker or thinner. I am always thinking of how to make them work together."

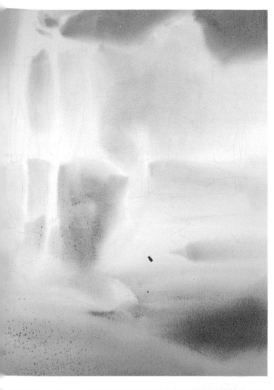

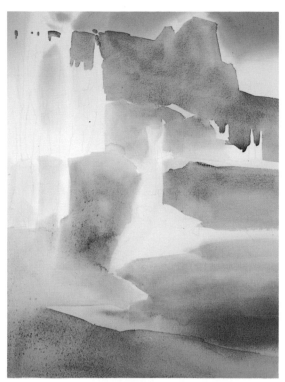

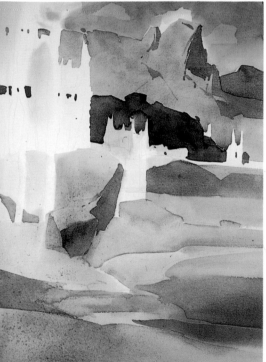

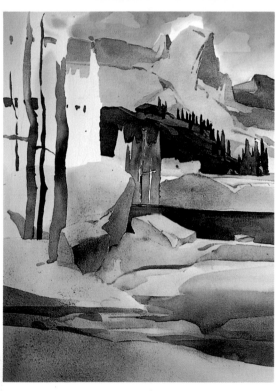

1 ◄ *On Arches rough paper stapled to a plywood board, Laitinen blocks the composition in lightly with pencil. Then with a 2-inch wash brush he wets the surface with water, then lays down a wet-into-wet under-painting*

2 ◄ *After the underpainting dries, he blocks in the large general shapes to indicate the subdivisions of the landscape.*

3 ◄ *After letting the surface dry, he introduces darker values with more specific shapes that start to give them form.*

4 ◄ *As he adds more detail, he defines shapes that will encourage eye movement in the piece. He offsets the vertical trees with horizontal lines across the ground and diagonals in the rock masses.*

TIPS FROM THE PROS

• A successful painting rests on the overall structure. No matter how well you paint the details, if the larger composition doesn't work, the painting will not work.

• On your thumbnail sketches, always draw in the edges of your composition. They are the four most important lines in the painting, as important as the center.

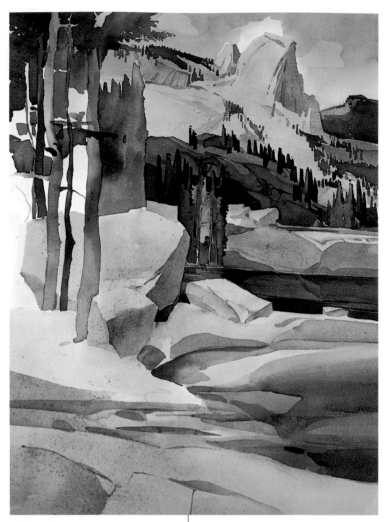

5 ▲ *Although he is not locked into his preliminary studies, Laitinen refers back to the value sketch to maintain the balance of shape and value he planned.*

Keeping the Eye Moving Through the Painting

Rather than a single focal point, Laitinen creates a series of large and small "hinge points." These spots of interest catch the eye and keep it moving through the painting.

He also establishes eye movement with the type of shapes he uses. Verticals, horizontals and diagonals all encourage the eye to move in a particular direction. For instance, if he has a horizontal shape going across the painting, he might add a vertical to change the eye's direction and keep it from leaving the picture plane.

He says, "I avoid visual arrows or strong diagonals that lead to corners or edges of the painting. You have to be aware of the edges. In my thumbnails I always draw in the edges. They are the four most important lines in the painting, as important as the center."

Five Things to Concentrate on From the Beginning

There are five things Laitinen concentrates on doing as he develops a painting:
1. Balance the shapes
2. Harmonize color
3. Make the eye flow
4. Simplify forms
5. Give the painting clarity

These are all well established in the early stages of the painting. The rest is just expanding and refining, developing a full range of values and adding just enough details to identify the subject.

"The routine of sketching and brainstorming at the beginning," he says, "helps center me and leaves me in a less frantic stage when the painting process begins. Though I have solidified my ideas, by no means am I locked into them. I do not want preconceived ideas to limit my growth on a painting; neither do I want to start without some notion of where I am going with my brush."

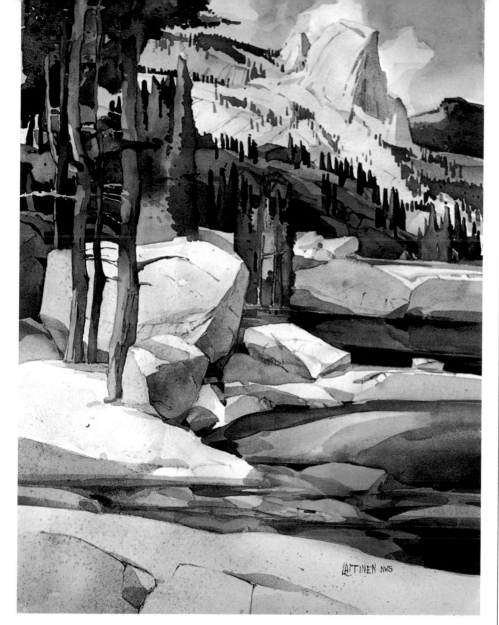

6 ◄ *With the colors and values in place, completing the painting is a matter of adding those details that will bring the scene to life.*

LIGHT CATCHER
Dale Laitinen, 30" × 22"

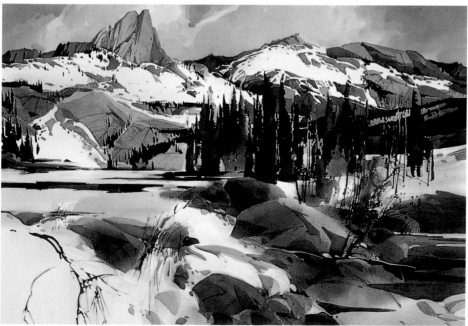

Placing the Lights and Darks
Much of the drama of this piece is created by the juxtaposition of very light and very dark values. As in the demo, Laitinen first worked out the placement of those values in preliminary sketches.

SIERRA SNOW
Dale Laitinen, 29½" × 41"

Martha Mans Shows You How To...

LOOK AND PLAN

Sketch 1

Mans feels the figures in her paintings are too important to be thrown in at the last minute, so she works out their position and gesture in preliminary sketches.

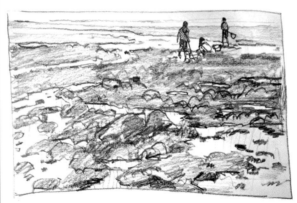

Sketch 2

She places the figures in the composition and determines major shapes and values.

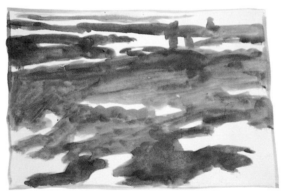

Sketch 3

In this diagram she simplifies the composition to light and dark. This helps her check the movement and balance of the piece.

I have tried not planning and find that in the middle of the painting, I don't know where I'm going." Thus Martha Mans explains why she takes the time to study an idea and draw it in her sketchbook before she begins to paint.

She is always looking for paintings wherever she goes, looking for subjects, but also seeing the shapes, color relationships and rhythms of shapes in nature. At least half of her painting time is spent looking.

Look for the Abstract Shape in the Subject Matter

The subject will suggest an abstract shape that becomes the understructure of the painting. After she sees the subject itself, she finds the design shape to build the painting on, and that shape becomes a dominant part of the painting.

"I make my students really look at the subject," she says, "and then turn their easels away. The subject is only there to get you started, to give you inspiration. You look to see how the shapes work together; then you use that to create the painting on your paper."

Plan the Gestures of Figures

Mans loves to include figures in her paintings. She says, "People have gestures, ways of holding themselves. I try to capture that body language even in small

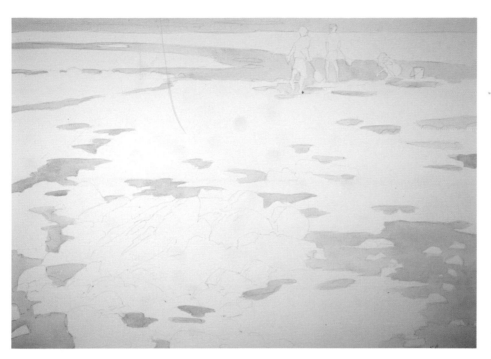

1 ◄ *Over a simple pencil sketch she places the blue areas of water throughout the composition.*

distant figures. When I paint people I'm familiar with, I can make it look like them even from a distance.

"A lot of artists put the figures in as an afterthought. I start with the figure. The figure is always my center of interest. Everything else is designed to enhance or guide your eye to that figure."

Start With Light Washes and Save Those Whites

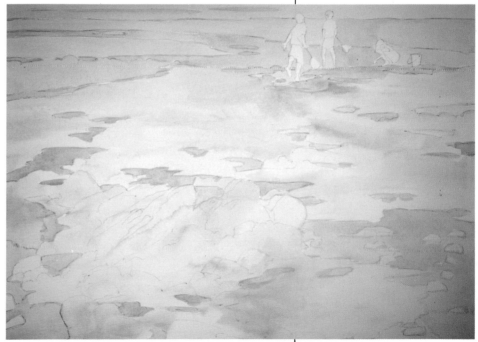

Mans's painting process generally includes four steps.

1. She lays in light washes over the entire painting, except those areas that will remain white. This gives her a sense of how the composition fits onto the paper.

2. She starts working on the shadow shapes, laying in all the middle values. Mans says she uses a lot of color here, and only partially mixes the colors on her palette. She likes to paint one shape and while the color is still wet, push or "charge" another color into that area. Another technique is to paint two colors next to each other and let them mingle on the paper.

3. She paints lines, small shapes and dark darks.

4. Finally she adds the details.

2 ▲ *She fills the sand and rock shapes with complementary warm colors. To begin to establish spatial depth she makes the colors cooler as they recede into the distance.*

3 ▸ *She paints in the figures and begins to refine the shapes of the rocks. She is careful to maintain the same direction of light in both rocks and figures.*

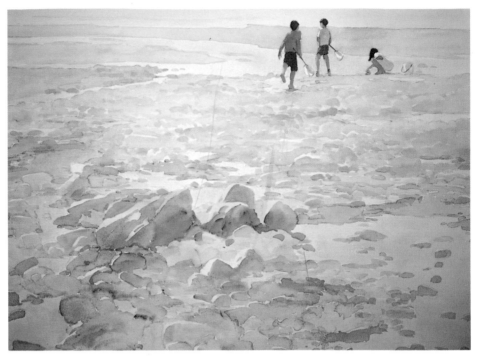

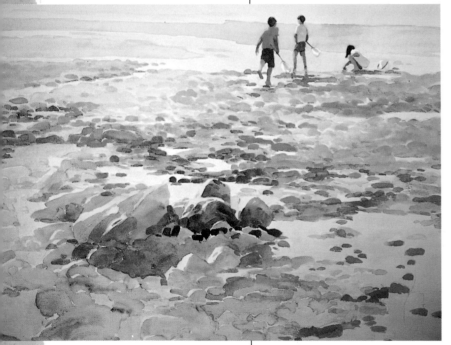

4 ▴ *As she develops color and value, she maintains greater contrast in the foreground than the distance, intensifying the spatial depth. The eye will be drawn to the figures, pulling the viewer into the depth of the painting.*

Lead the Viewer Into the Painting

One of her favorite parts of painting is planning how the viewer is going to look at a painting. She says, "I start with an entry point that leads the viewer inside the painting. Then shapes and the direction of lines lead you from one section to another until you reach the main center of interest. In each section there is a secondary subject where you will stop and explore that section before you are led off to another.

"Each painting has a front section, middle and distance. I lead viewers into the space of the painting so that they feel they are physically pulled into the picture."

Throughout the painting process she says she has to sit back and look at what's happening to see if it's going in the direction she wants it to go. She keeps a working frame handy to help her see the painting better. She says, "I've started over on a painting even if it's more than half done. If I lose the momentum, I don't try to keep forcing it."

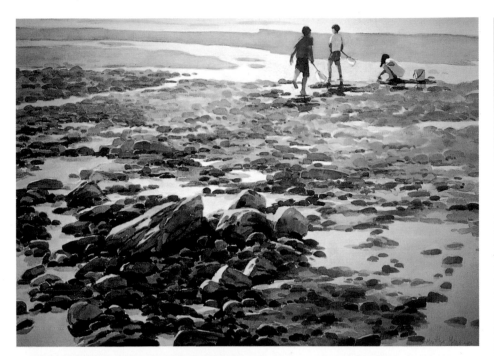

5◄ *In the finished painting you can see how closely Mans has followed the composition laid out in the preliminary sketches. Being definite about the composition from the beginning allows her to put down her paint strokes with assurance, thus achieving the sense of spontaneous brush work.*

LOW TIDE
Martha Mans, 18″ × 24″

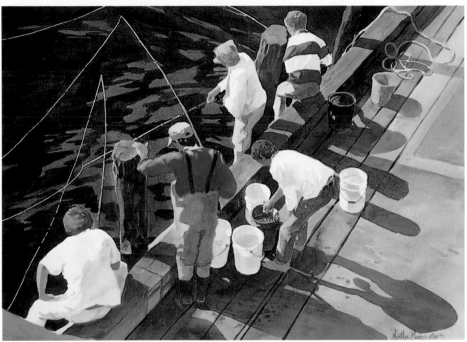

Balancing Shapes in a Sketch

It is often easier to see the compositional components of a piece in black and white than color. In the sketch for this painting Mans designed the cast shadows of the figures. In the finished painting you see how those dark shadows balance the dark green shape of the water.

CATCH OF THE DAY
Martha Mans, 22″ × 30″

Pencil Sketch
Stewart begins with a simple study to lay out the composition, which she describes as "rhythmic diagonals zigzagging to the church."

1 ▸ *She paints the focal point, placing the lightest, darkest and brightest colors in this center of interest.*

Penny Stewart Shows You How To...

PUT THE PUZZLE TOGETHER

P enny Stewart translates the richness of a realistic landscape into patterns of two-dimensional shapes that look like jigsaw puzzles. She captures the special light, color and texture of each place by painting translucent against opaque, bright against dull and light against dark.

Stewart says, "In choosing a location, I look for a view with a design. The design might suggest movement such as zigzagging hills or a serpentine path leading to a focal point. Other designs might include interesting patterns like diamond-shaped fields or undulating hills. I've used fence rows or tall poplar trees to add rhythm to my designs."

She makes a small, quick pencil sketch of the view to help her decide on the theme of her design, locate the focal point and the path she wants the viewer's eye to follow, and establish the arrangement of the largest shapes. She often alters the subject, moving shapes or borrowing objects from other scenes to improve her composition.

Divide the Composition Into Unequal Areas

Stewart divides the total space of the painting into unequal areas. She asks, "Is this going to be a painting about the land or about the sky?" Then that shape takes up the larger part of the composition.

After loosely transferring the drawing to her watercolor paper, Stewart begins the painting with the focal point. The focal point is generally a person or object that contrasts with the rest of the scene—a red truck in the middle of farmlands, a person walking in a garden. She places the lightest light, darkest dark, brightest bright and most interesting shapes in or near this center of interest.

"As I develop my painting," she says, "I work from the focal point in all directions. I pace constantly and look at the painting to assess how each new shape is enhancing the focal point and overall design."

Stewart works on paper that she has primed with extra sizing. This makes the surface less absorbent and allows her to easily remove unwanted shapes and colors. In this way she is able to work and rework a section of the painting and still have it look spontaneous. (See chapter two, page 25.)

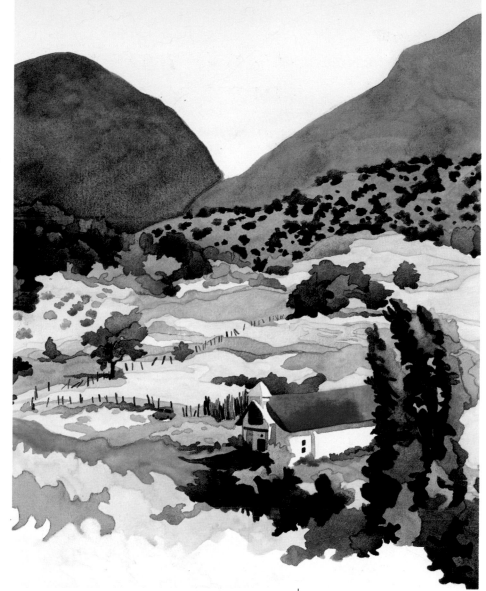

2 ▲ She works out from the focal point, developing textures and patterns in one section at a time.

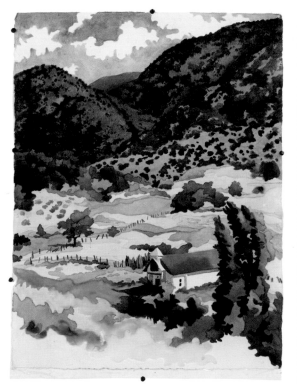

3 ◄ Another technique she uses to keep the painting from looking overworked is to lay a sheet of wet media acetate over the painting and try out particular shapes and colors before she actually adds them to her painting.

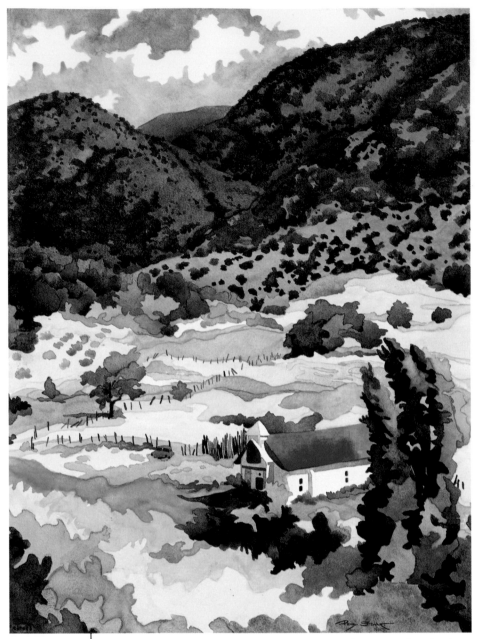

4 ▲ *Although this painting is loaded with interesting patterns and colors, the eye is still drawn to the church because of the bright red and stark white.*

IGLESIA EN PILAR
Penny Stewart, 30″ × 22″

Repeat Colors but Vary Them Slightly for Color Harmony

Stewart explains, "The three dominant themes at this stage are repetition, variety and contrast. To produce color harmony, I repeat colors but vary them slightly to create interest. For example, I may break a large field shape into smaller pieces of similar color and value.

"I achieve color contrast by placing warm against cool, bright against dull, opaque against transparent, and complementary colors next to each other.

"I place textured shapes next to smooth for variety. Techniques I use to create texture include:

1. using a sedimentary color that will settle into the paper's interstices
2. mixing colors that separate on the paper
3. dropping water or paint into a partially dry area to produce an 'oozle'
Overall, value contrasts are greatest at the focal point."

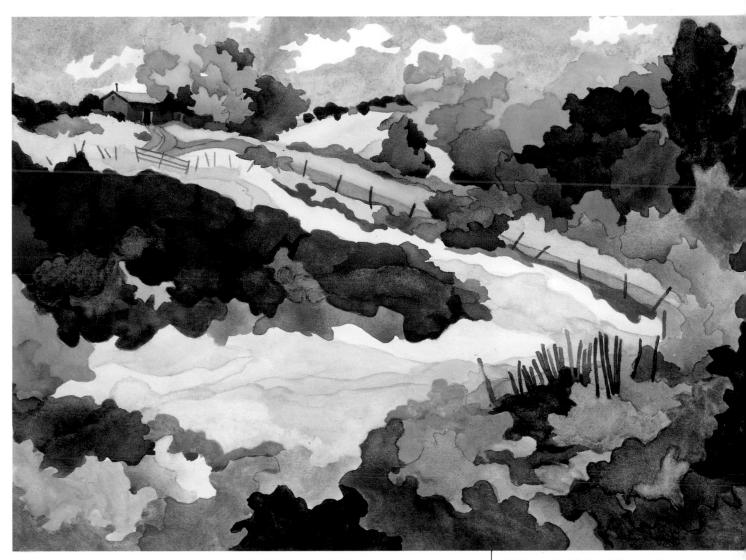

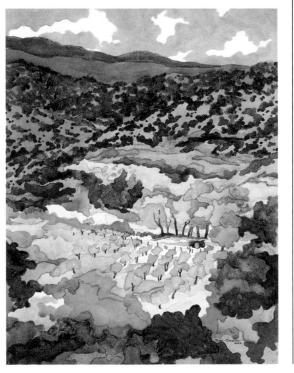

Follow the Yellow Diagonals
Even though Stewart's paintings are pieced together like a jigsaw puzzle, there is always a central theme to the composition. Here it is the diagonal swath of yellow that pulls the eye through the painting.

HONDO HACIENDA
Penny Stewart, 22″ × 30″

Colorful Contrasts
One of the most important compositional elements in Stewart's work is contrast. Notice how in this painting she contrasts large shapes against small, light against dark and warm against cool.

PRIMAVERA EN CORDOVA
Penny Stewart, 30″ × 22″

Seeing the Light

T he arrangement of lights and darks in a painting is like the skeleton—it supports everything else. Value is what gives form. It shows depth and atmosphere. It creates drama.

The most direct way of planning the arrangement of lights and shadows in a painting is just to look at what is there in nature. First, find your light source. In an outdoor painting it will generally be the sun. Then notice that everything closest to the sun is relatively bright; as things move away from the light source they gradually get darker. The side of an object on which the light is falling will be bright; the side where there is no light will be dark.

Composing With Light and Shadow

This is a wonderful example of the use of shadows as an integral part of a composition.

SHADE
Catherine Anderson, 22" × 29"
Collection of Curt Wilson

TIPS FROM THE PROS
- The arrangement of lights and darks in a painting is like the skeleton—it supports everything else.
- Use both the shapes of objects and the shapes of shadows to create an overall pattern of darks and lights.
- Long, angular cast shadows are particularly useful for guiding eye movement in a composition.

Study the Shapes and Nature of Shadows

I love to use shadows in planning a composition. Shadows occur where something is blocking the fall of light upon an object. The shapes of shadows are determined by the direction of the light and the shape of whatever is blocking the light and by the contour of the surface on which the shadow is falling.

It is helpful to understand something about light and shadows, but it is most valuable just to look at them. Observe light and shadows in different situations and at different times. Notice how the same view in nature will change over time as the sun moves.

A valuable exercise is to sketch the light and dark areas in a scene as the light changes. Draw a scene in nature as the sun moves, or set up a still life in your studio and periodically move a spotlight to different positions.

Another influence on the lights and darks in nature is the weather. On a bright, sunny day, shadows will be dark and very definite. On an overcast day they will be more subtle.

When I am creating the design for a painting, I use both the shapes of objects and the shapes of shadows to create an overall pattern of darks and lights. Long, angular cast shadows are particularly useful for guiding eye movement in a composition.

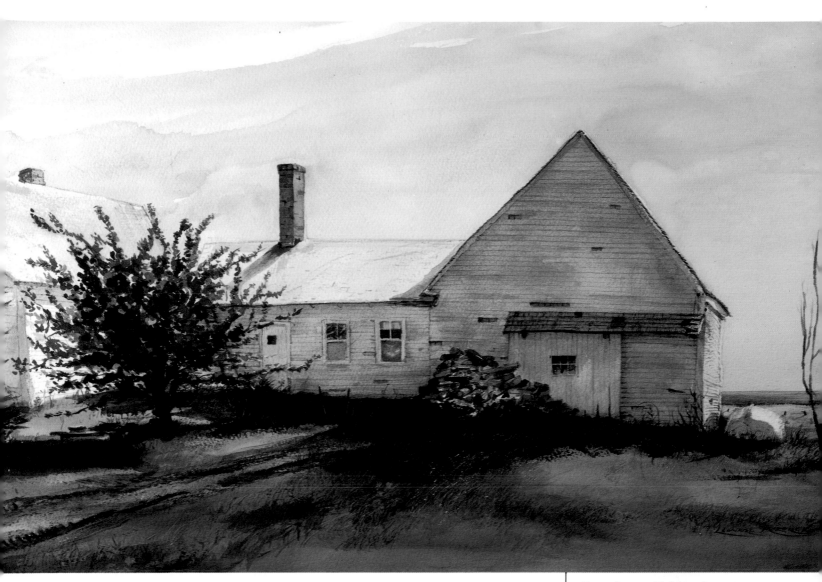

Separating Color and Value

One of the most difficult skills for a new artist to learn is how to see the values of colors. We automatically assume that some colors, such as yellow, are light and other colors, such as purple, arc dark. However, a deep yellow ochre can actually be much darker than a pale lavender. Values exist in relationship with one another, and the only way to determine a value is to compare it to other values.

A good way to assess your judgment of values is to look at a picture of a subject in color and decide which are the light, middle and dark tones. Then look at the same subject (with the same lighting) in a black and white photograph. Looking at an object through a piece of transparent red plastic will also show you the values by eliminating colors.

Focusing on Light and Shadow
It is the fall of light and shadow in this painting that gives the composition its strength. The bright light on the roof becomes a focal point and the cast shadows move the eye across the foreground.

TENANT'S HARBOR
Leonard Mizerek, 18″ × 24″

Compelling Contrast

Like most landscape artists, Sharon Hults knows that it is the way light falls on a scene that makes it come alive. This view is compelling because of the very bright highlights on the mountain peak and in the foreground, in contrast to the very dark shadowed areas.

AFTERNOON LIGHT
Sharon Hults, 30" × 40"

How the Pros Plan Their Values

Most professional artists plan their values before beginning a painting. A value study is particularly useful, even if it is as small as a thumbnail sketch. Simplify your subject to a few large shapes of black, white and gray. Only when you are satisfied with the arrangement of lights and darks should you begin the painting. Then keep the value study handy to compare with the painting as you proceed.

Values are just as important, if not more important, in abstract paintings when there is no representational subject. Many abstract artists also begin with a value study. Others—those who work in a totally intuitive way—must simply be very sensitive to the development of a strong value structure as they go along.

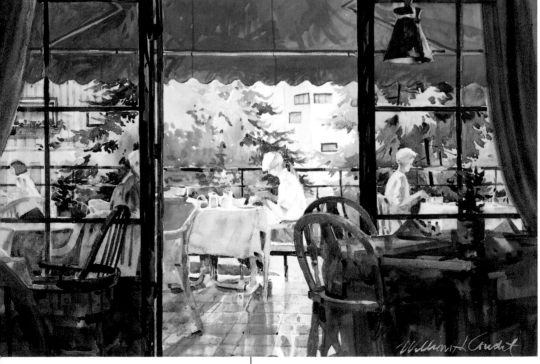

Unusual Lighting

Unexpected lighting can add tremendous visual interest to a painting. This subject becomes more interesting because the foreground, which is usually the brightest part of an image, here is in dark shadow.

BREAKFAST IN VAIL
William Condit, 15" × 22"

Values in an Abstract Subject
In this abstract painting it is the contrast of the pure white paper against the darker values of the painted areas that gives a dramatic punch.

NATURE'S HARVEST
Carol Surface, 11″ × 15″

Composing With a Value Study
Mans used this black-and-white study to help plan the value composition for the painting. Notice that only part of the newspaper and table top appear white. Part of the right side is in shadow, so that must be painted a darker color. Notice that the skin color also changes depending on how much light or shadow is falling on it.

SUNDAY FUNNIES
Martha Mans, 22″ × 30″

Working From Light to Dark

It is traditional in transparent watercolor to work from light to dark, and for good reason. It is much easier to make a section of the painting darker than it is to make it lighter.

What if you change your mind or realize that you mistakenly made a section too dark? Can you lighten an area?

Pigment can be lifted off by soaking or scrubbing an area and then blotting up the color with a sponge or paper towel. Small changes can be made by scraping dried pigment off the surface. In extreme cases, an artist will put the whole painting under a running faucet or hose and wash off the entire image. However, it is virtually impossible to return the paper to its original whiteness.

Opaque paints can also be used to lighten an area. Many artists combine gouache or white acrylic paint with their transparent watercolors. The challenge when using opaques is to make sure they look like a deliberate part of the painting and not a clumsy effort to cover up a mistake.

Begin With One Color
One way I have found to control the values in a painting is to lay in the value gradations first with one color. Here I have used layers of blue washes to show the shadowed areas.

When Values Are Established
After the basic value gradations were in place, I added washes of local color to complete the painting.

INVITATION TO DANCE
Carole Katchen, 18″ × 24″

TIPS FROM THE PROS
- Values exist in relationship with one another and the only way to determine a value is to compare it to other values.
- Simplify your subject to a few large shapes of black, white and gray. Only when you are satisfied with the arrangement of lights and darks should you begin the painting.

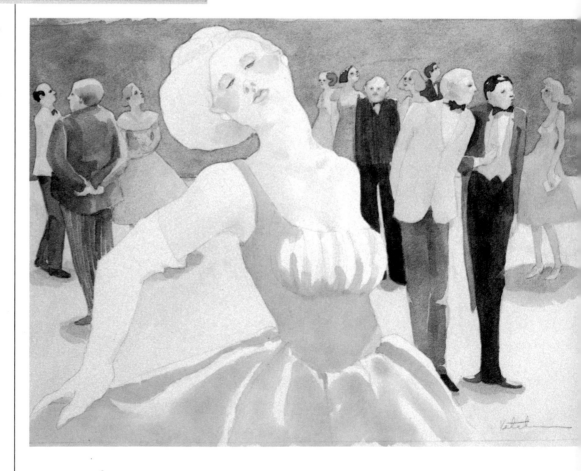

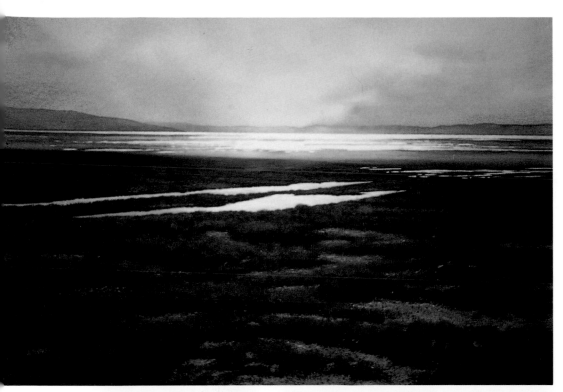

Contrasting Background and Foreground
The bright light on the distant water seems to shimmer because of the contrast with the dark values in the foreground.

BACK BAY LIGHT
Robert Reynolds, 25″ × 39″
Collection of Dr. Arthur J. Silverstein

Developing a Value Scheme
Although not completely accurate in their depiction of highlights and shadows, photos can be an excellent reference tool for developing the values in a composition as seen in this Lewis-Takahashi painting.

BUTTONS, BEADS & BOXES I
Jennifer Lewis-Takahashi,
23″ × 29″

Building Darks

To keep her dark values lively, Freeman built the "black" with combinations of primary colors rather than using a pure black. Dark darks can be achieved with watercolor either by layering many dark washes or by painting with highly saturated color.

MIDSUMMER'S NIGHT SCREAM
Kass Morin Freeman, 22" × 28"
Private collection, Rumson, NJ

TIPS FROM THE PROS
• Work from light to dark. It is much easier to make a section of the painting darker than it is to make it lighter.
• When using opaques, make sure they look like a deliberate part of the painting and not a clumsy effort to cover up a mistake.
• By placing a relatively dark value next to a very light value you can give the illusion of black.

How To Keep Whites Bright and Darks Lively

Brilliant lights are relatively easy to create, either by leaving white paper untouched or adding a light wash over the white. Darks are trickier. Some artists are able to create their darkest values with a single passage. They load the brush with a lot of dark pigment and little water, then leave the wash untouched until it dries.

Other techniques include dropping or charging more pigment into a dark wash before it has completely dried or adding more layers of color on top of dried washes. At times layering dark washes can leave the dark colors looking flat and lifeless.

To keep her darks vital, Martha Mans says, "For shadow areas, I never mix the colors together. That gives a flat color. I always push them onto the paper separately. It keeps the dark more transparent, luminous, more exciting."

Few artists actually use black because it is such a difficult color to control. Instead they combine various dark colors on their palette or on the painting to create a value that suggests black. By placing a relatively dark value next to a very light value you can give the illusion of black.

CAPTURE THE PERFECT LIGHT

Leonard Mizerek loves to paint outdoors, so he is always looking for good locations. However, the location itself isn't enough; it must also have the right light. He says there are certain kinds of lighting that help define shapes and forms as well as increasing the visual impact of the scene.

"I like side lighting or backlighting that casts long shadows," Mizerek says. "It creates new forms—interesting overlapping forms that make the composition more interesting. I like a stormy sky where the dark sky gives a dramatic contrast to the light foreground, or where a few sections of light break through the dark clouds. I don't like painting at high noon or in any other flat light. It seems to flatten everything out in tone and shape."

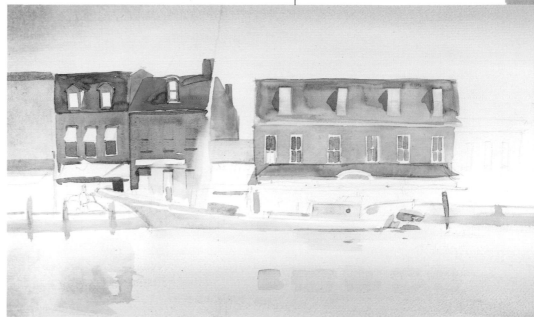

1 ▲ *Locating his whites Mizerek lightly establishes the other value shapes.*

What To Do About the Changing Light

"I find that lighting only lasts about two hours before the position of the sun alters what I'm painting," Mizerek explains. "Sometimes I'll start a painting early to give me time to prepare before I begin to add color. Then, when the sun is right, I'm ready to start painting. This gives me enough time to capture the shadows and capture the lighting that I want.

"If I see that the lighting is about to change, I'll quickly take a photograph so that I can finish the painting in my studio. Sometimes I'll return to the location at the same time the next day, but it's not often that all the conditions are exactly the same."

Mizerek tries to think about where the sun is, what's happening in the sky, and how that affects all the objects in the painting. He dilutes the color as it approaches the light source in order to show where it's brightest.

2 ▶ *Gradually, he intensifies the darker values, constantly checking the value relationships as he works.*

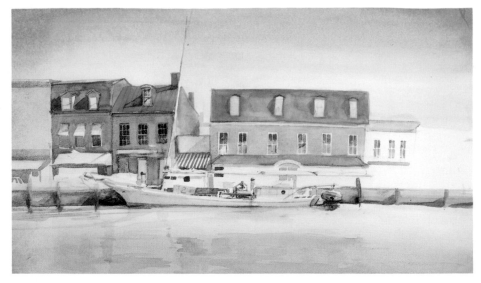

3 ▶ *Notice how the cast shadow of the boat becomes darker and more definite.*

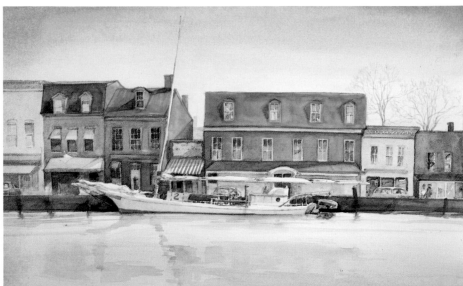

Handling Reflections on Water

Because so many of Mizerek's subjects include water, he is very concerned about reflections. Reflections show both the color and the value of what they are reflecting. He points out that water reflects not only the sky, but also anything that's on it and the shadow of the object. Reflections also show the wind factor. Still water will have more reflections. Reflections in unsmooth water will show the direction of the wind.

Start With a Value Study

A good grasp of value is essential for Mizerek. He says value helps establish depth by showing perspective and distance. It also helps direct the eye movement, with the focal point generally being where the darkest darks and lightest lights contrast against each other.

Before he starts to paint, he breaks down the values of the scene in sketches. Doing a black-and-white study helps break the elements down and gives him a different perspective of the view. As the painting progresses, he will often

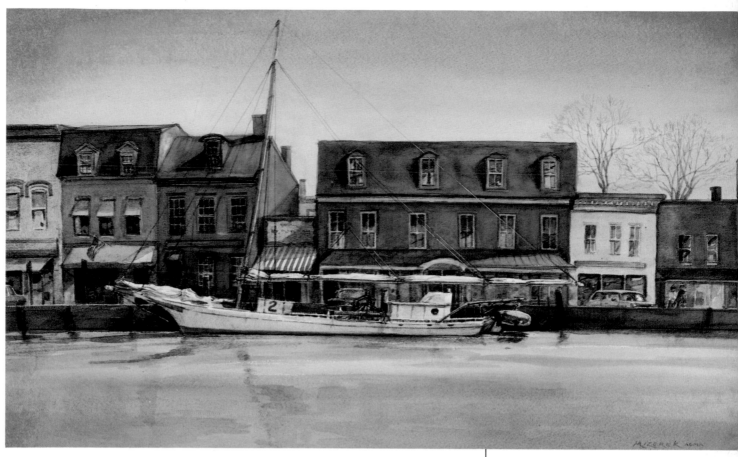

ANNAPOLIS HARBOR
Leonard Mizerek, 11″ × 14″

shoot black-and-white instant photos of the art to determine if he is maintaining the value relationships.

Planning for Change

No matter how well Mizerek plans a composition, he says there is always a possibility that the painting will change as he goes along. Sometimes he even adds more figures for more interest or more of a story. Before he adds a new element to the painting, he will paint it first four or five times in his sketchbook. Then he might cut it out and lay it on the painting to see if it will work in the composition.

"It's important," advises Mizerek, "to keep studying your composition and tonal relationships as you work in order to keep everything in balance. You don't want one thing to jump out too much. I keep critiquing myself as I work. A painting is like music. One painstaking note followed by another in perfect balance and harmony until the composition comes together to become a beautifully completed score."

Black-and-White Photo
It can be hard to assess the exact values of colors. To test the value relationships Mizerek shoots a black-and-white snapshot of the painting.

Photo of Subject *Chesapeake Skipjack*

In this photo you can see the subject from which Mizerek was working.

Pencil Study of *Chesapeake Skipjack*

In this pencil study he eliminates unwanted details and establishes a value scheme for the painting. He makes the trees a dark swath across the paper to provide a dramatic contrast for the light boat. The dark building becomes a light gray so that it will have less importance than the boat, which is the main subject.

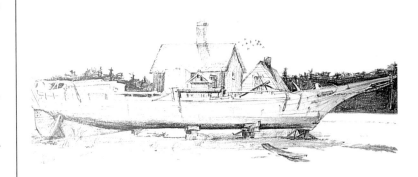

CHESAPEAKE SKIPJACK,
E.C. COLLIER
Leonard Mizerek, 14" × 24"

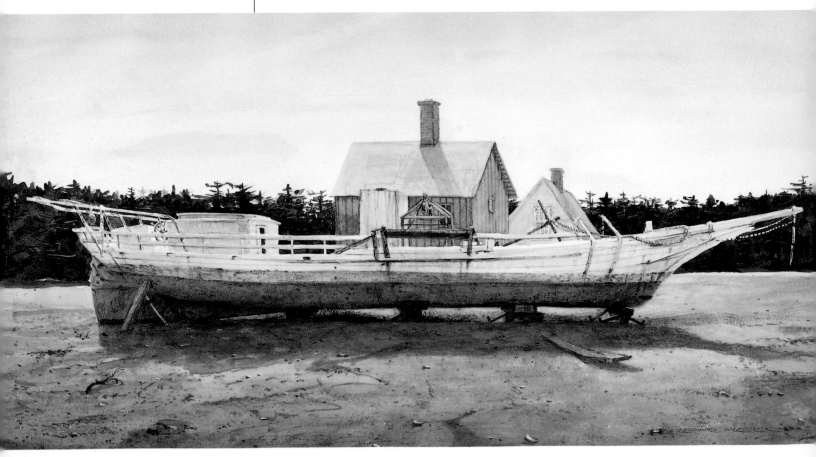

Linda L. Stevens Shows You How To . . .

CREATE LIGHT WITH LAYERS

L inda L. Stevens uses an extensive layering process in painting. She stacks many layers of transparent pigments on top of each other until the desired hue, value and intensity are achieved. "I have found that the depiction of light is better simulated in this indirect way than by directly mixing and applying color in fewer steps," says Stevens.

To create light, she works on the theory that "luminosity can be achieved by contrasting the three properties of color: value, intensity and hue. In sections of a painting that I want to be luminous, I make it lighter, brighter and complementary to the rest of the painting."

Use Three Basic Elements to Enhance the Light

1. *Value.* Lightness can be emphasized by putting darker colors around it.
2. *Intensity.* Make colors outside the area of interest appear duller by mixing complementary color into them to gray them.
3. *Hue.* Surround the focal point with complementary colors, to make the whole area appear more brilliant in color.

Stevens says, "The light is the difference between a subject that works and a subject that doesn't. There's a magic in how light hits an object. Especially in early morning and late afternoon, there is a magical quality in the warmth of the light and the cast shadows.

Establish a Center of Interest

"Most of the time," says Stevens, "my center of interest is the lightest area of the composition. I add subordinate light areas to help move the viewer's eye to the focal point

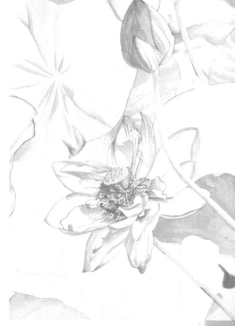

1 ▲ *Working on Arches 300-pound rough paper, Stevens lightly draws the image with pencil. Since she develops her colors and values with many layers of mostly primary colors, she begins with the warmest and most opaque—Cadmium Yellow Pale and orange. She places these wherever they will be needed in the finished painting or wherever they will be needed to influence another color (such as yellow green).*

2 ◄ *She adds a third warm color, Alizarin Crimson. You can see that the layering is not only developing color, but is also creating a range of values.*

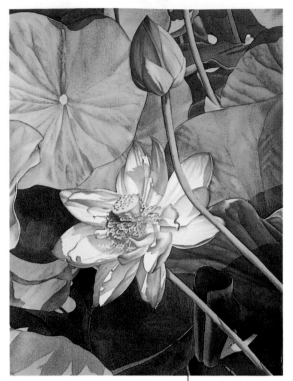

3 ▲ *By washing transparent green over the previous colors, Stevens gets a wonderful range of greens in the foliage.*

4 ▶ *Adding layers of blues makes the cooler, darker areas of the background begin to recede.*

either by the value or the direction of light flowing across that shape. The shapes of light and shadow get even more weight than the shapes of the objects."

Using Light to Create a Mood

Stevens also uses light to create a mood. If she wants the painting to have a light, lyrical look, she keeps all the values close to each other in the light to middle value range. If she wants more drama, she uses greater value contrast. However, she says, "Most of my paintings go from white to almost black. Some people think my paintings are not transparent watercolor because of the extreme value range."

Because of the large size of her paintings, Stevens is unable to work on location, so she uses her camera as her sketchbook. For six paintings of La Jolla Cove, she took four hundred slides. She says it's also important to study the actual location, because slides are not accurate in color. She explains that we can see into the upper ultraviolet range with the eye, but the camera can't; it misses some of the blues.

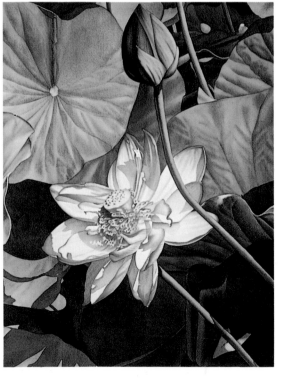

The Temperature of Light

Knowing that the kind of light establishes color temperature as well as value, Stevens sometimes begins by putting a very pale wash over the entire painting to show the temperature of the light. Although the temperature of light is often very subtle, she says you can learn to see it by just continuing to look.

Unlike many artists, Stevens does not believe that if the light is warm, all the shadows are cool and vice versa. She says it depends on what colors are bouncing around in the painting. You can have warm colors reflected in cool shadows and cool colors reflected in warm highlights. And because she sees the shadows as dark areas with many colors reflected in them, she never uses a neutral black. She always uses colors for the darks—to keep them alive.

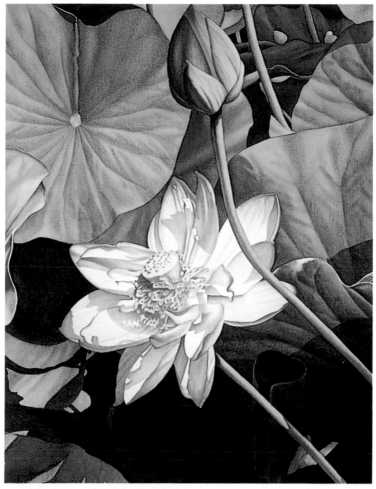

5 ◄ *The final step is adding a dark, dull blue-green (Winsor Blue, Ultramarine Blue, Alizarin Crimson and Burnt Sienna) to intensify the darkest values.*

HAIKU #21
Linda L. Stevens, 25″ × 18½″
Collection of the artist

Reflections of Light on Water

This is one of a series of thirty-seven paintings Stevens did of rocks and water to explore the reflections and refraction of light on water. She likes to work in series so that she can thoroughly examine a subject.

WATER LIGHT #33
Linda L. Stevens, 29½″ × 42″
Collection of the artist

CHAPTER FIVE

Maximizing Color

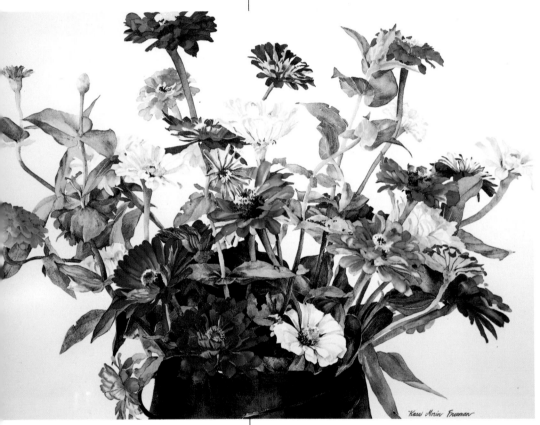

Color Is Relative

Colors exist in relationship, appearing brighter or duller due to surrounding colors. By leaving this background pure white Freeman allows the colors of the flowers to appear their most brilliant.

ZINNIAS
Kass Morin Freeman,
21" × 29½"
Collection of Mr. and Mrs.
Rudolph Forst, Lansdale, PA

Many novice artists seem to think that professionals have a secret list of perfect colors. If they could only find the "Right" colors for their palette, then their paintings would look professional. So they go to workshop after workshop and jot down the name of every color the demonstrator uses. Maybe this combination of colors will be the solution.

The truth is that *any* color is the "right" color, depending on how and where it is used.

We see a color in relationship, never by itself. It is always surrounded by other colors, and it is those other colors that make it look right or wrong. Surround a cadmium red with gold and orange and it may look flat, but put that same red next to a cool blue and suddenly it will pop off the paper. As Linda L. Stevens says, "Color is really relative. A section may begin to look muddy, but I know that when I put down the darks surrounding it, the colors will come back to life."

Pros Know the Color Basics

Any serious artist should know at least the basics of color theory so he or she can put colors together in the most interesting and powerful way. I don't think you have to learn each color's chemical makeup and degree of light refraction and all those other scientific minutiae; after all, you're not sending a rocket to the moon here. However, you should know cool and warm colors, primary and secondary colors, and complementary colors. And you should understand

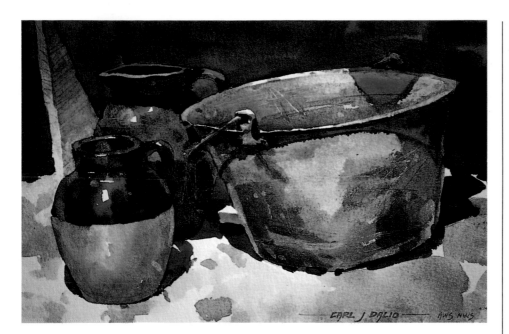

the hue, value, intensity and temperature of a color, and how they work together.

Leonard Mizerek gives an example of how color theory can be used to create spatial depth in a painting, "Warm colors come forward and cool colors recede. Also, I use complements to control depth by graying a color to recede. You don't have to blend the colors completely. It makes it exciting to see some of the red in the green."

Some Examples of Professionals' Palettes

Most professional artists do have a list of colors that they prefer, but the list is derived from their own experience of what works and what doesn't work in their own paintings. I have included a few here to give you a sense of how varied these professional palettes can be.

Dale Laitinen: His palette contains these Winsor & Newton colors:

Cadmium Yellow	Cadmium Red
Winsor Red	Rose Madder Genuine
Alizarin Crimson	Cobalt Blue
Cerulean Blue	Cobalt Turquoise
Yellow Ochre	Burnt Sienna
Winsor Green	Chinese White

The Richness of a Limited Palette
It is possible to give the impression of rich color without using a lot of different colors. This painting was executed with only two colors—Alizarin Crimson and Sap Green.

CONVERSATION IN SOHO
Carole Katchen, 9″ × 12″

Organic Color
Osa's approach to color is to keep it as close to nature as possible. He avoids high-intensity colors in favor of a palette of more natural colors.

BUILDING STORM
Douglas Osa, 28″ × 40″

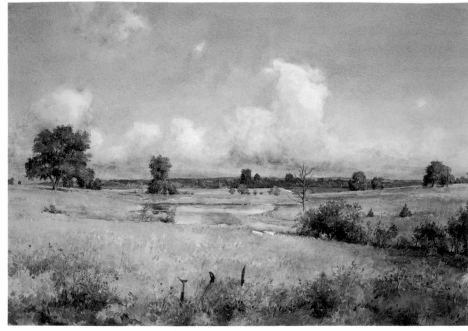

Building Colors With Layers
Rather than mixing her colors on the palette, Stevens blends colors by layering washes on the painting. She begins with washes of yellow and red, then adds layers of cool colors.

FEATHER LIGHT #9
Linda L. Stevens, 42″ × 29½″
Collection of Aryna Swope

Douglas Osa: "I like an organic look to my color. I don't use a high-intensity palette. And my palette is simplifying. I am down to only about ten colors and I might not use a couple of those. Usually, I'll use a couple of bright blues and cadmium Yellows, Yellow Ochre and Burnt Sienna. I use Indian Red or Mars Violet rather than Alizarin Crimson."

Linda L. Stevens: "I use few colors on my palette, preferring to 'mix' the colors I need through layering. I have a palette of primary and secondary colors and two earth colors. Most of the pigments I use are very transparent. Those few that are more opaque (Cadmium Yellow and Cadmium Orange) are used early in the layering process. My palette usually consists of Alizarin Crimson, Winsor Red, Cadmium Orange, Cadmium Yellow Pale, Winsor Green, Winsor Blue, Ultramarine Blue, Yellow Ochre and Burnt Sienna."

Penny Stewart: Penny Stewart points out that there are other qualities to pigments beyond the color. She says, "The learning curve is steep because there are sedimentary pigments, staining pigments and opaque pigments. The only way to learn what they will do is to practice." She uses the following Winsor & Newton colors:

TRANSPARENT COLORS	SEMI-OPAQUE
Rose Madder Genuine	Cadmium Yellow
Permanent Rose	Cadmium Orange
Viridian Green	Cadmium Red*
Aureolin Yellow	French Ultramarine Blue*
Cobalt Blue	Cobalt Violet*
	Manganese Blue*

STAINING COLORS

Alizarin Crimson
Winsor (Phthalo) Blue
Winsor (Phthalo) Green

OPAQUE

Lemon Yellow
Naples Yellow
Cerulean Blue*
Indian Red*
Light Red Oxide

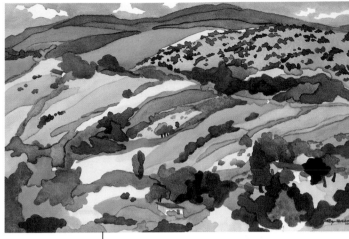

*These colors are also sedimentary.

Martha Mans: "I try to stay away from formulas, but I do generally stick to the same colors for skin—Permanent Rose and Raw Sienna. I pick up a little bit of New Gamboge (yellow), and charge Cerulean Blue into the shadow areas. I use the same colors only darker for shadow areas, or add violet for shadows in distant figures.

"For darker skin, I use Cerulean Blue, Permanent Rose and Raw Sienna; for darker flesh tones a violet or Cobalt Blue and Red Rose Deep mixed with Burnt Sienna. I bring in Cobalt Blue here and there to keep the shadows from looking flat. Don't mix the Cobalt Blue in, just place it on the paper.

"I use a heavy concentration of paint, and in order to keep that transparent, stained-glass look, I keep the colors separate."

Color and Texture

Stewart points out that in addition to a variety of colors, there are sedimentary, staining and opaque pigments and each of these will create a different surface texture. Looking closely at her painting, you can see the variety of textures.

VISTA DE VALDEZ
Penny Stewart, 15″×22″
Collection of Celine Krueger

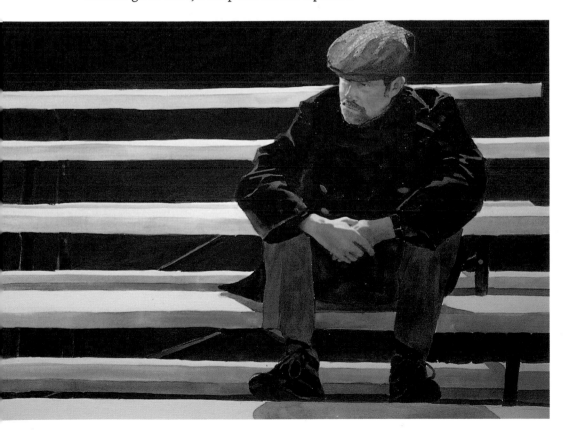

Contrast Complements

Mans gives her palette of colors more punch by contrasting them with their complements. Notice the yellow against purple.

YELLOW BLEACHERS
Martha Mans, 22″×30″

Load the Brush for Rich Color
In order to get this brilliance of color it is essential to use a brush that is loaded with pigment.

PALM GROVE
Carl Dalio, 26½″ × 20″
Collection of Leroy Springs Co.

TIPS FROM THE PROS
- Any color is the right color depending on how and where it is used.
- You achieve harmony by placing related colors near each other—yellow next to orange, blue next to green.
- Repeating colors within a composition and limiting your palette also add to the overall harmony.
- Use a "mother color." That is color that you blend into most of the other colors in the painting. Often the mother color will be the color of the light.
- Use opposites to set colors off from each other and increase their luminosity.
- We see a color in relationship to other colors, never by itself. One color is always surrounded by other colors, and it is those other colors that make it look right or wrong.
- There are two elements that make up the successful use of color—contrast and harmony. Contrast is what makes the color interesting. You can contrast cool colors against warm colors, light colors against dark colors, brilliant colors against dull colors.
- Emphasize the focal point of a painting by giving that area the greatest color contrast.
- A wonderful type of contrast that is sometimes overlooked by the watercolorist is brilliant against dull colors.

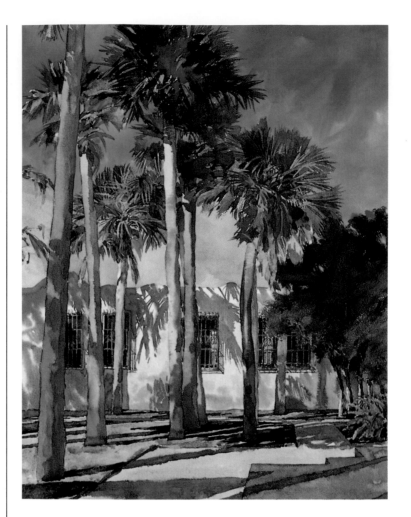

Mixing Colors Masterfully

Some artists work with dozens of tubes of color. Others have only three—a red, a yellow and a blue—and mix everything else from those. Studying a color wheel will give you the basic information about what combinations of colors create other colors. However, to really understand the blending of colors, there is no substitute for practice.

Squeeze small amounts of paint onto your palette from any two different tubes of color. Put a tiny amount of one of the colors and a much stronger amount of the other color onto your brush and make a stroke on a sheet of dry, white paper. Vary the amounts of each color until you have strokes on your paper of the full range of colors you can blend from those two tubes.

Repeat the process with other combinations of two and three colors, jotting down on your paper which colors were used for each sample. By the time you are done, you will have a much stronger sense of how to mix colors and you will have a reference chart of how to recreate those colors at a later time.

Of course, with watercolor there is another important factor as well. That is the amount of water you mix into each stroke of pigment. Try different colors with various amounts of water mixed in. Notice also how the color changes from the wet stroke to the dry stroke. Often a color appears more intense while it's still wet, so when you are painting, you might have to increase the amount of pigment you use.

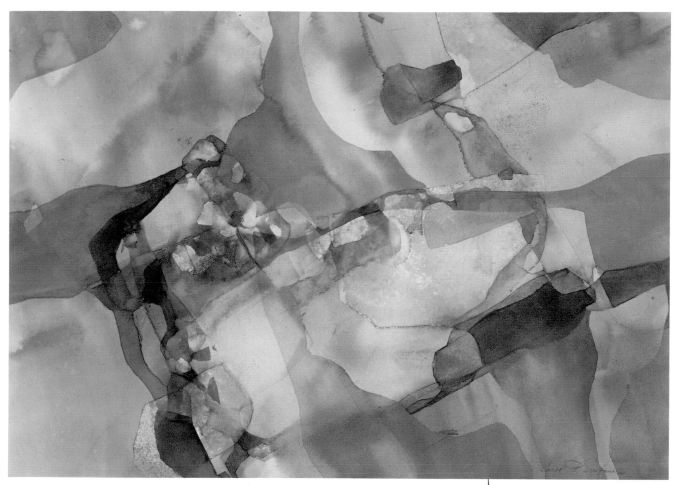

A Bit on Blending

The most obvious way of blending colors is with your brush on the palette. You want a green area for grass. You dip your brush in blue then in yellow, you blend it on the palette and then you brush it onto the paper. Voila! You have green grass.

There are other ways of blending colors, however, that can give different effects to the surface, movement and mood of the painting. For instance, you could paint that grassy area blue and while the paint is still wet, drop or charge yellow paint into it. The paint will mix on the surface of the paper. Up close you will see that the yellow and blue pigments are separate, but from any distance the area will look green. The advantage of this technique is that it creates more visual interest and often keeps the colors looking fresher and brighter.

Adding Glazes

Another technique for blending colors is glazing. First you could lay down a wash of yellow. Let it dry and then go over it with a wash of blue. You can add more glazes of yellows and blues until you get exactly the color and value you want. This is a technique that takes longer, but gives you more control.

Flowing Colors on Wet Paper
By painting on wet paper, this artist is able to drop colors next to each other and let them flow into each other to create interesting new colors and textures.

PASSING GLIMPSE
Carol Surface, 22″×30″
Collection of Mr. and Mrs. Wally Barrows

Repeat Colors for Overall Harmony

With so many different objects in her still lifes, Lewis-Takahashi relies on color harmony to unify her compositions. Look at how she repeats colors throughout the composition.

THE OVERSEER I
Jennifer Lewis-Takahashi,
23″ × 27″

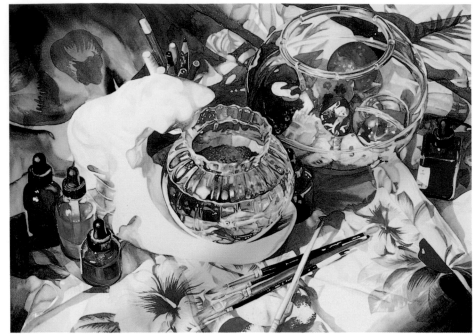

Contrast Brilliant Against Dull

Bright colors appear even brighter near grayed colors. Notice how the red pops out on the right side of the painting.

CHINATOWN
Eric Wiegardt, 30″ × 22″
Collection of Dennis and Doris Hudson

Use Contrast And Harmony for Paintings With Punch

There are two elements that make up successful use of color—contrast and harmony. Contrast is what makes the color interesting. You can contrast cool colors against warm colors, light colors against dark colors, brilliant colors against dull colors.

An effective way of emphasizing the focal point of a painting is by giving that area the greatest color contrast. For instance, if you juxtapose a strong yellow against a strong purple, that area will immediately draw the viewer's eye.

A wonderful type of contrast that is sometimes overlooked by the artist who works with transparent watercolors is brilliant against dull colors. Many watercolorists seem to have a phobia about muddy colors, so they avoid graying any of their colors. However, gray colors, colors that are blended with their complement, can add a valuable quality to watercolor painting. Any color will seem much more brilliant if it is surrounded by colors that have been grayed with a bit of their complementary colors. On the other hand, if a total composition is painted with just bril-

liant colors, the overall effect of the painting can be dull. It is contrast that gives your paintings punch.

Using Related and Repeated Colors

The danger of contrast is that if you use too much contrast in your colors, the viewer's eye will see only the color and not the painting. So you want to balance the contrast with harmony.

You achieve harmony by placing related colors near each other—yellow next to orange, blue next to green. Repeating colors within a composition and limiting your palette also add to the overall harmony.

Another method is to use a "mother color." That is a color that you blend into most of the other colors in the painting. Often the mother color will be the color of the light. For example, if the light illuminating a scene is yellow, the artist might lay a wash of yellow over the entire painting.

The Color of Light
During his outdoor painting sessions, Osa has observed how the color of the light affects the entire scene. Notice here how the warm sunset colors of the sky also tone the colors of the fields.

HAY BALES AT SUNSET
Douglas Osa, 21″ × 21″

TIPS FROM THE PROS

- Any color will seem more brilliant if surrounded by colors that have been grayed with a complementary color.
- If you use too much contrast in your colors, the viewer's eye will see only the color and not the painting. Balance the contrast with harmony.

Carl Dalio Shows You How To...

BE BOLD WITH PERSONAL COLOR

Photo of Site
Whenever possible Dalio paints on location. He says it is vital to have personal experience of your subject.

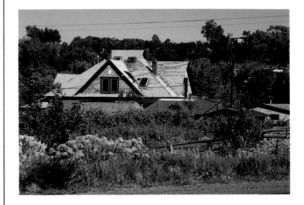

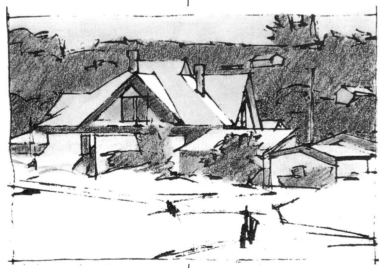

Value Study
Using pencil and charcoal he simplifies the scene to basic value shapes.

One of the things that makes Carl Dalio's paintings so delightful is the unexpected use of color—that splash of bright red in the sky, orange in the tree, red-violet in the shadow. You just never know what colors will appear where and that makes each of his paintings an adventure for the viewer.

At first glance the unconventional colors might appear arbitrary, but Dalio assures us that they really are there in his subject. His color choices come from looking long and hard at each subject until he sees the subtle colors that we usually overlook.

Dalio says, "I do a lot of observation. I look for the color that is first not apparent in the subject and then push it beyond the envelope of reality. It's a personal goal to make things work in a way that is not ordinary. It's important to get enough pigment into the mixes. Be bold in putting enough pigment together to make your stroke. Color is food for the eye and the mind. It should be edible. It should be delicious."

Build a Library of Painting Ideas

To be an effective artist, Dalio says he must have firsthand experience of his subject. He explains, "On-location painting from life or specific site is ideal in my book. Due to circumstances or a busy schedule, that is not always possible. In such cases, I either make notes and sketches or use my camera to record a personal experience for use down the painting road. This way I am always building my library of painting ideas.

"I keep a folder of any ideas that come along. When they come to the

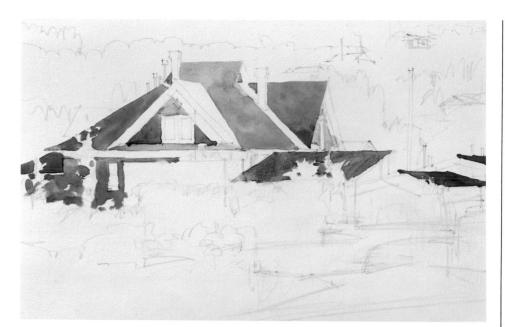

1 ◄ On 300-pound Lanaqua-relle cold-pressed paper Dalio lightly draws a pencil sketch of the subject. He then begins to lay in the first colors. Notice how he places a variety of colors into each of the wash areas, allowing the colors to flow together on the paper.

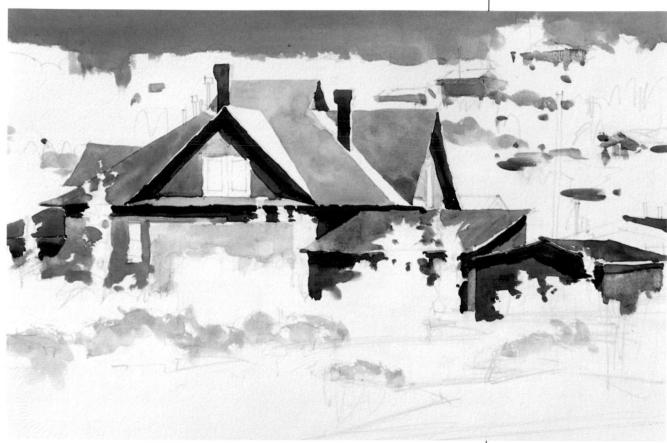

2 ▲ He places colors through-out the format so that one section will not be completed before the others. He sees the painting in three planes—fore-ground, middle and back-ground—and develops them all simultaneously.

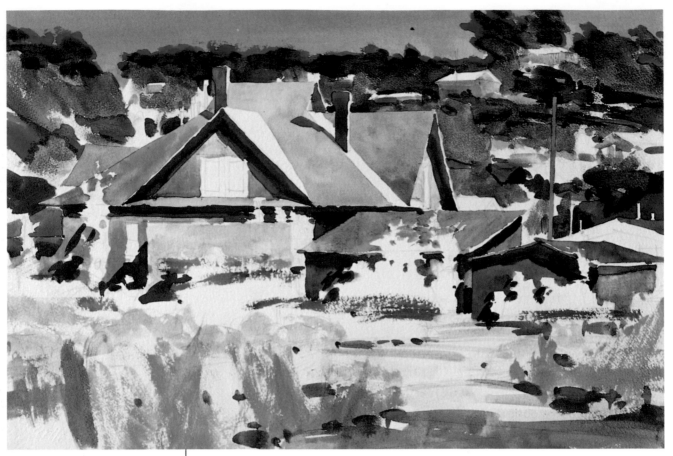

3 ▲ *Dalio says that the colors he chooses are all suggested by what he actually sees in the scene. He looks for the subtle variations of reflected light and color to help him find more interesting colors for everyday objects.*

surface, it's a good idea to latch onto them. They may not surface again."

He starts each painting with thumbnail sketches to work out the composition. The value study is a good way for him to simplify the subject. He says, "My goal is to put down the fewest strokes in stating the concept and revealing the subject."

He explains that after a long time of doing architectural illustration and being caught up in the client's need to see all the details, he now craves simplicity. He only includes those details that give authenticity to the subject or strengthen the focus of the painting.

Let the Color Lead You

After the composition is worked out, he thinks about color. He says, "I may put one color in the painting and then step away and look at it. I let that color lead me. Painting ought to be a joyful thing. It should bring the adrenalin up. I don't know that the puzzle is going to come together, and I may have to paint the thing over two or three times."

He concentrates on color temperature, using opposites to set colors off from each other and increase their luminosity. He uses complements to increase the vitality of his paintings, but he warns not to overuse them or your painting can become a three-ring circus.

He generally works on dry paper so he can make each stroke an individual statement. Occasionally he wets an area of the paper for a large wash or puts color into wet color, mixing on the paper and allowing for "happy accidents."

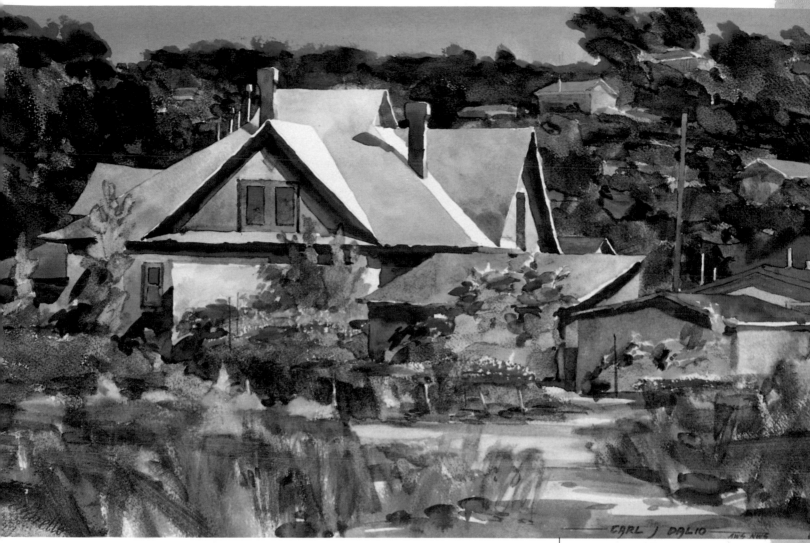

4 ▲ *In the finished painting you can see that the brightest colors and the strongest value contrast occur near the center of interest. Notice, for example, how much brighter the greens are in the house area than in the foreground.*

THE FLOWER GARDEN—
NORTHERN NEW MEXICO
Carl Dalio, 14½″ × 22½″
Collection of the artist

Kass Morin Freeman Shows You How To...

FIND SUCCESS IN A SIMPLE PALETTE

1 ▸ *Freeman begins with a small value sketch (right). Next, she washes very pale glazes of yellow and violet onto the paper to give warmth to the highlights. When the paper is dry, she draws masking fluid onto the places she wants to keep light for final highlights.*

2 ▴ *From the beginning she paints one side warmer and one side cooler. Notice how the sky goes from a warm gray on the right to a cool gray on the left. She also works to make one side darker (left) and one side lighter (right) in order to avoid total symmetry in the piece.*

According to Kass Morin Freeman, "It doesn't really take a lot of colors. It's value that makes a painting work. Color adds the emotion."

For her basic palette Freeman simply uses one or two reds, a yellow and three blues: Cool Cerulean, Primary Cobalt and Warm Ultramarine. She says Aureolin Yellow is a cool transparent yellow that works well for light. She often uses it to wash in her brightest areas because she says "plain white paper doesn't say anything." Using yellow, or another color in a soft wash, gives an emotional punch to the light. She protects those lightest areas with masking fluid tape.

For cool reds she prefers Alizarin Crimson and Brown Madder Alizarin, but she warns, "Watch out for them. They are fugitive colors. I never frame with glass any more. Regular Plexiglas filters out 43 percent of the ultraviolet rays and UV Plexiglas filters 98 percent. It's also important to educate your collectors not to hang paintings toward a window."

When painting florals she expands her palette so that less mixing is required for the brilliant colors. A red flower may be Alizarin Crimson (cool), Alizarin Carmine (less cool) and Winsor Red (warm). An orange bloom may go from New Gamboge to Cadmium Yellow to Bright Red. She rarely mixes the color complement into a flower to avoid getting the color muddy or dulled. Instead, she places the complement in the color that surrounds the flower.

3 ◄ *She creates the greatest value and color contrast in the area that will be the center of interest.*

Five Things to Keep in Mind

Freeman says, "Once I get my composition solved and drawn in a small value sketch, I keep five things in mind when tackling a watercolor painting; and if I get these things right and spell my name correctly, I usually end with a successful painting."

Those five things, which Freeman develops in order as she paints, are:

4 ▲ *She creates a stencil with pieces of mat board and tape and sprays color onto a section that she wants darker.*

1. *Defining light and space.* Besides the value shapes of the light and shadow, she lays in washes to show the light's color.

2. *Warm side, cool side.* Since warm colors tend to come forward and cool colors to recede, she creates spatial distance by dividing the painting into a warm side and a cool side. Within those color sides the distant shapes will be cooler and the closer shapes warmer. For instance, on the cool side the distant colors may be a cool green and then come forward through blue to a violet for the closest shapes. On the warm side they might go from blue-violet in the distance to red up close.

3. *One side darker; one side lighter.* This avoids the bland composition of a totally symmetrical painting.

4. *The most contrast at the center of interest.* The extreme contrast will draw the eye to the focal point.

5. *Less contrast as you move away from the center of interest.* This also supports the focal point.

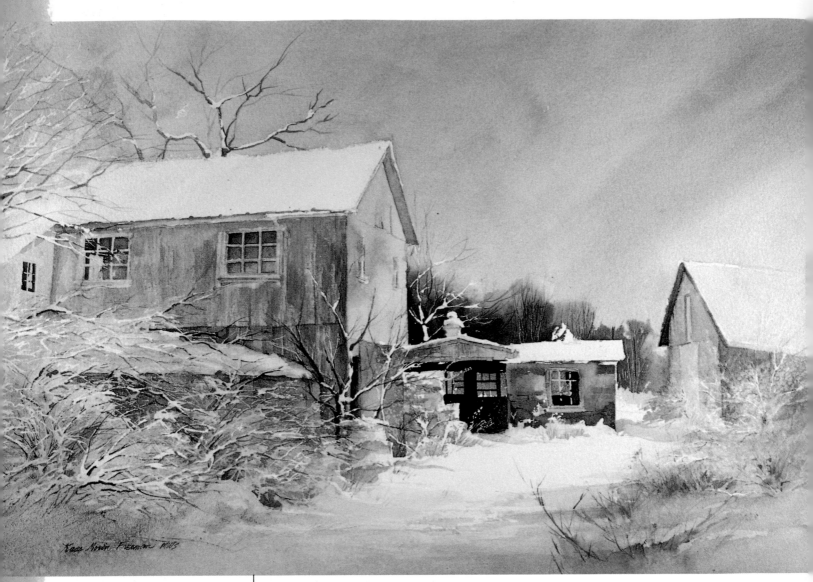

5 ▲ *Finishing the painting is a matter of removing the dried masking fluid and completing the details.*

RALPH'S CORNER I
Kass Morin Freeman, 16″ × 24″
Courtesy of The Handcrafter
Gallery and Studio, Telford, PA

Making Color Choices
Freeman painted the same subject with a blue palette to show how color choices affect the emotional impact of a painting.

RALPH'S CORNER II
Kass Morin Freeman, 20″ × 28″
Collection of Mr. and Mrs.
Robert Fortier, Dover, DE

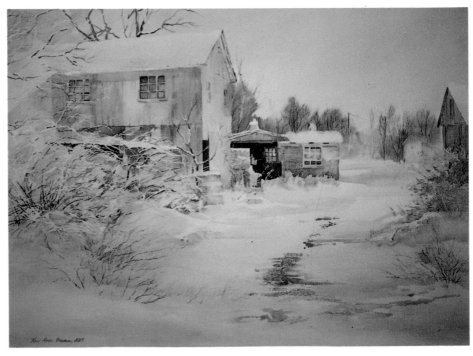

Douglas Osa Shows You How To...

CAPTURE NATURAL COLOR

Douglas Osa's approach to color is simple—use whatever it takes to capture the subject in front of you. Since his chosen subjects are natural landscapes, his palette consists of basic natural colors. He worries that the more brilliant, intense colors will actually detract from his subject.

Osa has painted with oils as well as watercolors, and he uses some of the same techniques for both. For instance, he likes to paint on a toned surface, so he begins by tinting his paper with a very light wash. He might leave some areas of white or he might cover the entire surface with very soft tone. Sometimes he will paint on a piece of paper that contained a failed painting. He scrubs off the previous painting until all that is left is a light tone.

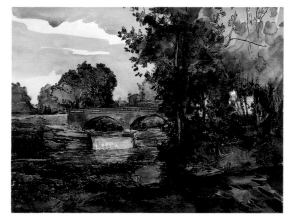

Color Study
"Early morning and late afternoon lighting conditions," explains Osa, "are especially beautiful because of the longer shadows and richer color caused by the low angle of the sun. These times of day also require quick, accurate decisions and decisive work to get down all the necessary information [in a color study such as this] before the light has changed."

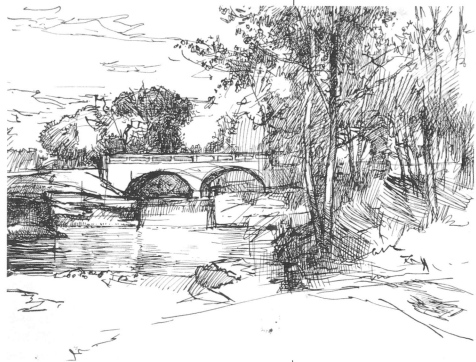

Divide the Composition Into a Few Simple Shapes

From there he divides the painting into large, simple color shapes, keyed to what is actually in the scene before him. He indicates the areas of dark and light color, and warm and cool color. He uses a very diluted paint at this point so that he gets a neutral, washed-down version of the finished piece.

Value Study
In this sketch Osa works out values and proportions. With these two studies he is ready to begin the painting.

This lighter version of the color allows him to see how the composition will fit together, but still gives him room for refining and enriching color as he goes along. Dividing the total composition into just a few large shapes of color also helps him develop color harmony.

Catching the Subtleties of Nature

He paints on location as much as possible. He says there is no way a piece of film can capture the subtleties of colors outdoors. The film will skew the colors warmer or cooler. Light areas will wash out and dark areas block up. If weather conditions are impossible for watercolor, he paints his color studies in oil and then paints the larger, more finished piece in the studio in either watercolor or oil. He feels there is no difference in importance between his watercolors and oils.

"The actual painting process is very traditional," he says. "I generally start the picture wet-into-wet, strengthening color and blotting until the composition is fully established.

"Where there is complexity of shapes and/ or values, this is preceded by a light, careful drawing. I actually do most of my drawing on top of the initial washes of color. The reason for this is that in the past I was tightening up on details before I was completely satisfied with the color development. What resulted was a stiff, tentative expression devoid of the subtleties that abound in nature. By eliminating the initial drawing I can concentrate on color harmonies and tonal transitions.

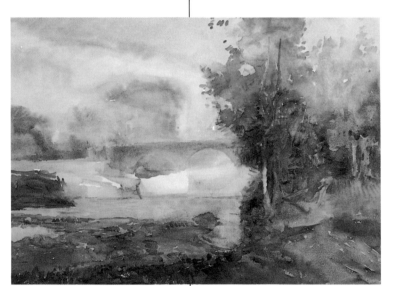

1 ▲ He begins by wetting his paper. When it is no longer glistening, he lays in large, flat washes of local color. As the paper dries, the strokes begin to hold their form.

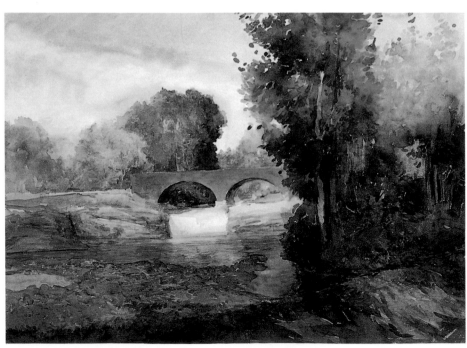

2 ▶ He continues to strengthen the local color and deepen the value contrast between foreground shade and the fully lit waterfall and bridge.

3 ▲ *Osa continues to add color and texture until the painting projects the atmosphere of the original scene. He picks out final bright highlights by scratching with a knife point.*

TRYST FALLS
Douglas Osa, 21″×29″

"Once dry, this color can be manipulated through lifting, dry brush and additional washes. I make use of gouache and body color (transparent watercolor with a little bit of Chinese White added to it) in some of my paintings, but never to simply paint out mistakes. Those I generally scrub out with a bristle brush and clean water. I've found the translucent quality the opaque color imparts to the transparent washes to be especially nice, particularly in the neutral halftones."

Preserving a "Sense of Place"

Osa avoids the "tricks of the trade," such as salt and spattering, for the same reason that he avoids high intensity colors. He doesn't want anything to interfere with his capturing the "sense of place" unique to each location where he paints. He believes that technique should never get in the way of the image.

He says, "My painting techniques are as simple as you can make them, just brushes and paint and paper. I may draw lines in with a knife while the paint is still wet, but that's about as complicated as I get. I really don't think there's any way to get around good strong drawing and brush handling, and a good eye for color."

Know Your Subject

Begin With a Memory
Lewis-Takahashi's inspiration begins with a memory. Then she builds up a collection of objects that reflect it. Her next challenge is to unify the complex still-life with a main shape for the composition. Look at the circular movement in this piece—the greeting cards (above) create a V that points down to the oriental doll shape. The string brings the eye back up to another greeting card, the large wooden box and planter. Then more strings lead the eye back to the first greeting cards.

BUTTONS, BEADS & BOXES II
Jennifer Lewis-Takahashi,
31" × 40"

Professional artists can find subjects anywhere—on the highway, in the backyard, in the closet. Wherever there is something to see, there is something to paint.

What makes a subject a *good* subject is that it has some quality that holds the attention. It could be the shapes or colors. It could be a mood or memory the subject evokes. It could be the arrangement of light and shadow. Something about the subject grabs the attention and then holds it there while the viewer explores the scene.

The artist must be interested in the subject in order to project that visual excitement to the viewer of the painting. There must be a personal connection between the subject and artist, either aesthetic, emotional or intellectual. If it is a landscape, it must be special to you in some way. A generic scene will produce a generic painting.

One of the greatest challenges for an artist is to paint a commissioned piece when the subject has been chosen by the collector. In order to make that painting work, the artist must find some personal point of connection with the subject. Otherwise, the painting will be lifeless.

What to Do When Your Interest in a Subject Fades

Sometimes a subject seems interesting to an artist until halfway through the painting. At that point all the problems have already been solved or the artist is no longer interested. You can't decide whether to use a warm red or a cool red, because you just don't care.

You have several choices. You could press on, hoping that inspiration will miraculously reappear. From my own experience, I would say this is unlikely. When I force myself to finish a painting I don't care about, the finished piece is always disappointing.

You could put the painting away on the chance that at some point in the future you will be interested in it again.

You could rip it up or turn the hose on it.

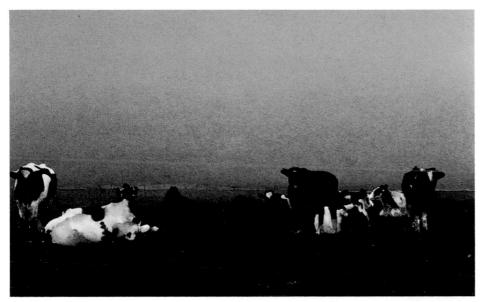

A Moody Subject
Anderson layered one hundred glazes of color to get the right color and density for the fog— the real subject of this composition.

SENTIENT BEINGS
Catherine Anderson, 22″ × 30″

Turn Typical Into Dramatic
By adding intense lighting and imaginative color, Dalio turns this cityscape into a dramatic composition.

FLATIRON
Carl Dalio, 27½″ × 21″
Collection of Eric C. Dalio

Or, and this is the most useful approach for someone who is painting for a living, you could change something in the subject so that it becomes more interesting. Change the lighting or color scheme, for instance. Move the main objects closer or farther away. Change the background.

I had this problem once when I was painting a group of women. I liked the figures, their gesture and placement, but the whole painting had become boring to me. Suddenly I thought of moving the lighting behind them. Backlighting is always dramatic with figures because the figures become darker than the background and take on the mysterious quality of silhouettes. Then I was able to finish the painting with excitement and joy rather than a sense of drudgery.

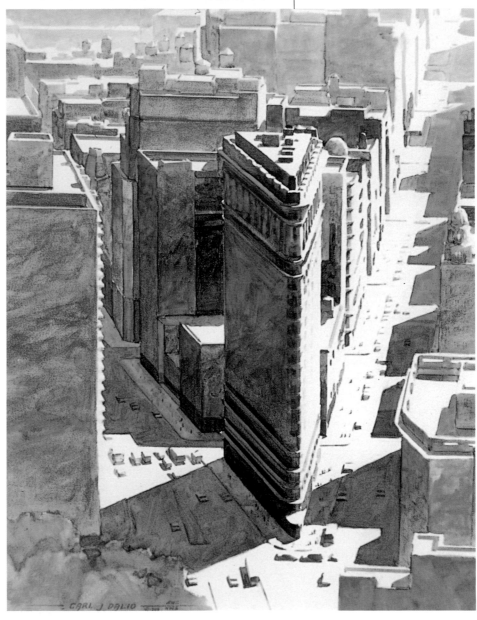

An Unlikely Combination
Often the combination of un-likely objects, such as a flower with machinery, creates a sub-ject more interesting than either of the objects alone.

GRIM REAPER
Kass Morin Freeman,
24½″ × 38″
Courtesy of DeVirgilis—Fine Art,
North Wales, PA

Change a Point of View
A trite subject like a bowl of fruit can be made exciting by chang-ing your point of view.

APPLES & PEARS
Carole Katchen, 11″ × 14″

Are Some Subjects More Professional Than Others?

No. The professionalism appears in the handling of the subject.

Some subjects have been done over and over again in exactly the same way. There is a triteness to them, just because the image is so familiar. Many florals are that way: a simple arrangement of flowers in a vase set smack in the middle of the composition with a simple background and flat lighting. It doesn't matter if you have never done a painting like this before, it still looks trite because so many other artists have.

What you can do to make the piece look more professional is take that basic subject and add an unusual twist. Light it in a dramatic way; turn off all the lights in your studio except for one spotlight shining directly on the flowers. Or, move the vase to the side of the composition and give more attention to the cast shadows on the table or wall. Or get very close to the flowers and focus on the negative space between the blossoms.

As a professional artist your job is to make the viewer look at your painting. Most people are lazy; they don't want to look at anything. You must make your painting so intriguing, so vital or so finely executed that the viewer cannot resist it.

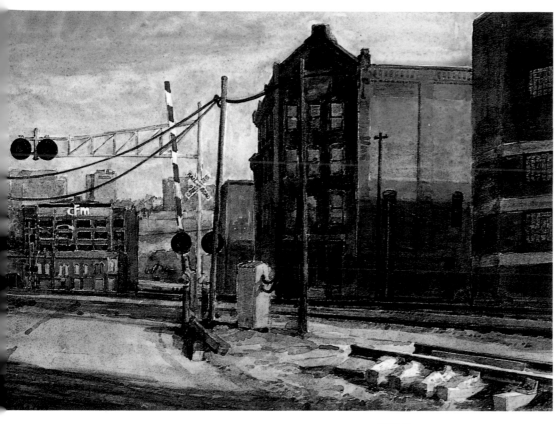

Try It First With a Sketch
One way to see if a particular scene will work for a painting composition is to reduce it to black and white in a preliminary sketch.

UNION STREET
Douglas Osa, 10¼″ × 14¼″

Getting to Know Your Subject

Knowing your subject well is crucial. Doug Osa says, "I may spend several days just driving around a new area in the morning and the afternoon to see the light. Then I go back with a sketchbook and really experience the place. I get to know that spot better, sometimes over a period of years, so that I know in October the light in this location is just right."

Whenever possible take the time to observe your subject before painting. Making sketches not only records reference material—it helps you know the subject better.

Over the years I have spent many hours in marketplaces in Africa and South America. I always take the time to make sketches in pencil or watercolor, because I know that I am learning things about the scene that could not be recorded in a photo. How it smells. How it sounds. How the people interact. These things give personality to my paintings of the market.

If you use photographic reference material, make sure you have plenty. Shoot different views of the same scene. Get close-ups of details. Change your exposure so you record subtleties of light and shadow. You will probably not want to use all of the details you record, but with so much reference material, you are able to choose those details that best describe your subject.

TIPS FROM THE PROS
- There must be a personal connection between the subject and artist, either aesthetic, emotional or intellectual.
- A generic scene will produce a generic painting.
- Whenever possible take the time to observe your subject well before you begin painting.

Study for Lighting
As simple a subject as a cluster of rocks can become the basis for a dynamic painting when the artist adds dramatic lighting. Reynolds works out the pattern of light and shadow in a preliminary study before he begins to paint.

STILL WATERS/SUMMER BLOSSOMS
Robert Reynolds, 27″ × 38″
Collection of Dr. Donald Rink

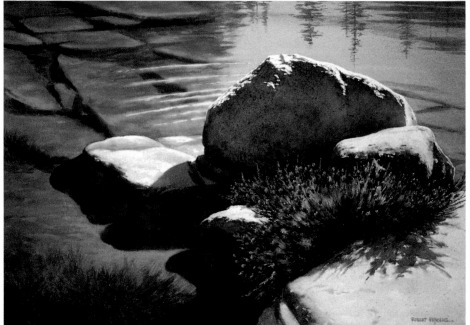

Observing Other Places
William Condit recommends traveling for finding interesting new subjects.

THE CONSTITUTION
William Condit, 15″ × 22″

TIPS FROM THE PROS

- Making sketches is not only a way of recording reference material, but it also helps you know the subject better.
- Take the time to make sketches in pencil or watercolor—you will learn things about the scene that cannot be recorded in a photo. How it smells. How it sounds. How the people interact with each other. These things will later give personality to your paintings.

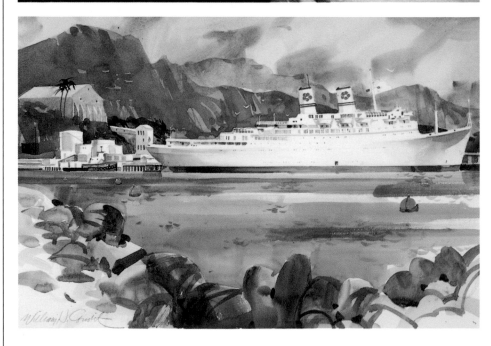

Study a Subject Through a Series

When Linda L. Stevens finds a subject that is interesting she uses it for a series of related paintings. One advantage of working in a series is that as she becomes more familiar with the subject, she can use the paintings to work out more and more subtle challenges of light and color.

HAIKU #10
Linda L. Stevens, 29½" × 42"

HAIKU #3
Linda L. Stevens, 29½" × 42"

HAIKU #17
Linda L. Stevens, 36½" × 60"
Collection of Janie C. Shen

Finding Your Market
*Martha Mans's paintings are
lively—and successful—
because she paints subjects
that she's interested in—in this
case, figures.*

MARKET DAY
Martha Mans, 28″ × 20″

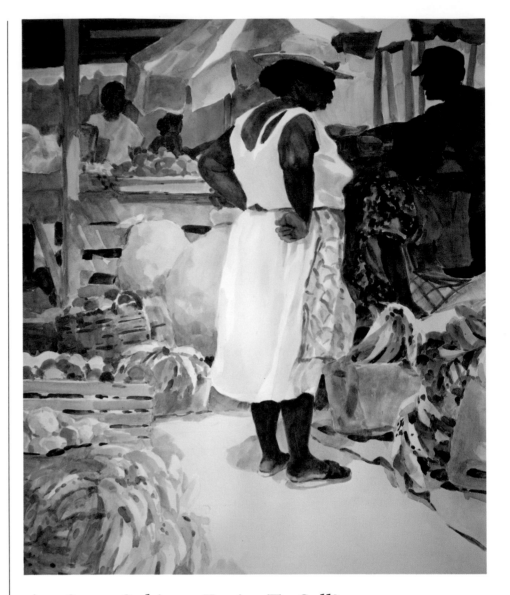

TIPS FROM THE PROS
- If you use photographic reference material, make sure you have plenty.
- Choose those details that best describe your subject.
- Paint what you love; you will find a market.
- When you paint for how you think others will respond to your art, you begin to lose the personal connection you have with your paintings.
- In the looser paintings it is the precision of the few chosen details that convinces the viewer of the subject.

Are Some Subjects Easier To Sell?

Definitely. Most art dealers would agree that landscapes are the easiest paintings to sell. However, I believe that there is a market somewhere for every artist and every subject.

It is commonly agreed that figures are hard to sell, but I have been supporting myself quite nicely for years painting people. There are artists who are successful painting fish or steam engines or Victorian women. Paint what you love; you will find a market.

Choosing your subjects just because you think they will sell is very dangerous. When you paint for how you think others will respond to your art, you begin to lose the personal connection you have with your paintings. You lose your passion and eventually you lose the joy of painting.

DISCOVER THE SUBJECT

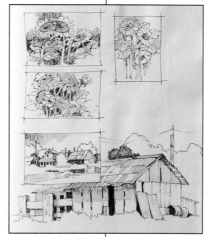

M ary DeLoyht-Arendt says, "Painting for me is not so much *recording* a subject as it is *discovering* a subject." This is an especially notable statement because after years of painting flowers, she still finds that each painting of flowers helps her learn more about them.

DeLoyht-Arendt worked for a long time at Hallmark Cards in the drawing department where she had to be precise about details and shapes. In her current paintings she is much more likely to brush in an abstract shape of color to suggest a group of flowers rather than meticulously render individual blossoms. However, she says that even in the looser paintings it is the precision of the few chosen details that convinces the viewer of the subject. The shape of a rose leaf is different from the shape of a geranium leaf and her years of precise training makes it easy for her to show those differences with just the shape of a stroke.

Record Observations With a Travel Sketchbook

DeLoyht-Arendt is constantly looking for new subjects and sketching whatever she sees even when she is traveling in the car. She says, "My husband invented a table that fits in the front seat of our car. It is covered with carpet

Three Illustrations From Sketchbooks

The sketchbook is one of Mary DeLoyht-Arendt's most valuable tools. She uses it to record ideas for future paintings, to make notes on colors and values, to work out and record details, and to develop compositions. Although she also uses photographic reference material, the sketches record many things that cannot be captured on film.

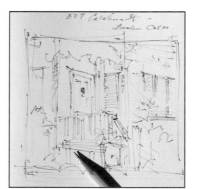

Preliminary Sketch for *Summer House*

Working on location, the artist begins with a sketch of the subject. By drawing the composition first she is able to get a better sense of how the subject will fit into her format.

1 ▸ *DeLoyht-Arendt lightly draws the subject onto her paper, then quickly lays in the shadow areas with a 2-inch brush. Since the light changes quickly, it is helpful to place the shadows and highlights first.*

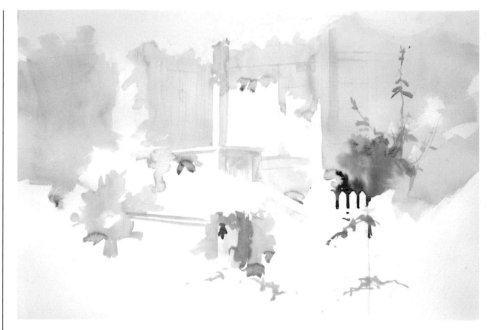

2 ▸ *She then begins to add details of architecture and foliage. She points out, "Because I work upright, the pigment will run down, drying lighter and flatter, so I have to compensate for this later in the finishing stages."*

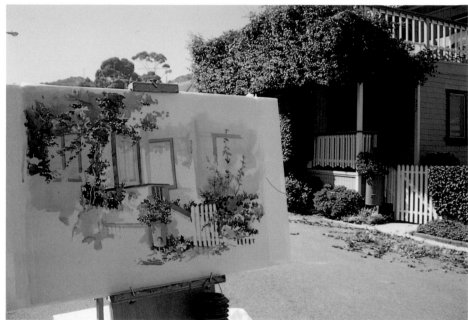

so that the sketch book does not slide off and there is a hole for a small water container.

"On trips I use a pen or pencil or a small travel watercolor palette and paint to sketch the different things I see along the way. I sometimes write comments about color and where it was sketched. It's like a diary and comes in handy on days I can't go out to paint or for demo ideas."

Her sketchbook is an invaluable tool. She uses it to record general ideas and observations as well as details. She learns how a flower is constructed as she draws it and even if she doesn't paint all the detail later, the knowledge makes it much easier for her to be convincing in her paintings. She explains, "You know it in your head; so you can paint it with a looseness that suggests that shape."

Designing Negative Shapes

She also uses the sketchbook to plan compositions, what to put in or leave out, how to place the subject on the paper. She records bits of color and value and begins to design negative shapes. She says, "Observing the negative shapes is so important in painting flowers. I often paint around the shape rather than painting the shape itself. I find I'm less controlled if I concentrate on the abstract shape around the subject."

DeLoyht-Arendt stresses the importance of basic art skills. In judging art shows she often sees paintings by beginners who start at the end, throwing on color before they know how to draw or pull a composition together. They tend to rely on color and techniques to hide their lack of other skills. Even if there are few details in the painting, they must be drawn well or the work lacks conviction.

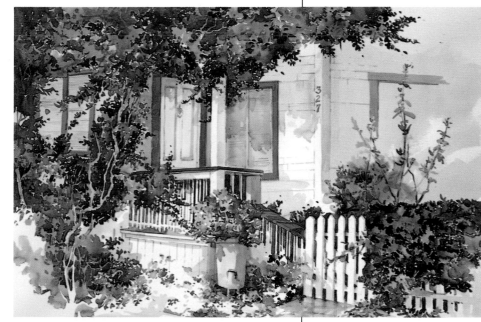

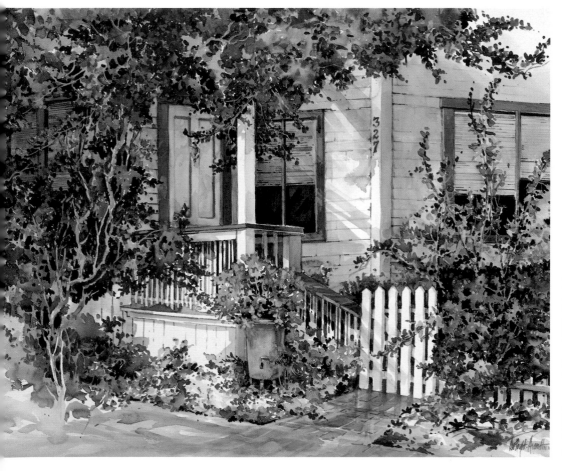

3 ▲ Unexpectedly, the occupants of the house came outside and started trimming drastically. DeLoyht-Arendt says, "It became a race: who could paint or who could cut the fastest. The artist has the advantage. We can add whatever and wherever we like."

4 ◄ She completes the painting, adding the finishing touches to balance color and design in her studio.

SUMMER HOUSE
Mary DeLoyht-Arendt, 22" × 30"

Jennifer Lewis-Takahashi Shows You How To...

PAINT A MEMORY

Assembling a Composition With Photos

Lewis-Takahashi begins by assembling and photographing a collection of objects. She looks particularly for objects that have personal meaning to her and objects that provide a technical challenge. She often combines several photos for one image.

1 ▲ *She projects the negatives of the color photos onto her paper (300-pound Lanaquarelle) and draws with pencil the outlines of the objects and details. She begins painting with a focal point and works out from there, completing each area as she goes along.*

One of the hardest things for a beginning artist," says Jennifer Lewis-Takahashi, "is figuring out what to paint. You have to find what speaks to you. What is important in your own life? There are no big statements, only what is important to you."

For Lewis-Takahashi, each subject must be important enough to her to spend a month to seven weeks—from 120 to 150 hours—to complete it. She finds those subjects in memories and objects from her everyday life that she combines into large, intricate still lifes.

She says, "I might be lying in bed and I remember that thing my mother used to sprinkle laundry with. I wonder what ever happened to it. I think it might make a good painting and then I start to wonder what would go with it."

She begins with a memory and then looks for objects that fit together with that memory. She chooses objects based on color, size, shape and texture, always conscious of how they will look together. She says, "I go to estate sales and borrow things from people. I was doing a thing on fortune-telling. I wanted a Ouija board, but not a new Ouija board; so I started asking all my friends."

Create a Challenge

She also looks for objects that will give her a technical challenge, such as the reflective surfaces of glass or metal, or a piece of crumpled-up cellophane. She explains, "I try to create a technical assignment for myself for each subject,

2 ◄ *Within each section she indicates shadows and reflections with light washes first and then develops details and richness of color.*

such as creating a large consistent dark area, contrasting a coarse texture with a smooth one, representing translucence as opposed to transparency.

"I like to make it hard. I've already figured out a lot of technical challenges and I've had to make them harder and harder. I want to keep learning and growing."

Working With Photography

She arranges and rearranges the objects for a variety of compositions and then photographs them with colored print film. She works with

3 ▲ *The artist says, "I try to vary the way I spend each painting session—part of the time in meticulous detail, as in the cards; another part doing general washes, as in the background areas.*

natural light so that the viewer will have the sense of opening a door to a room and finding these objects lying there. From any given set of objects she might choose two or three of her favorites so she can do a small series of the subject. She says that allows her to work out the technical kinks without beating it to death.

She puts the negative of the chosen image into a slide mount and projects it onto a sheet of 300-pound Lanaquarelle. Projecting the negative rather than a slide helps her reduce the image to abstract shapes and crucial details, which she draws onto the paper.

She warns, "I wouldn't recommend projection for someone who hasn't already established a strong background in drawing. Photos don't necessarily tell the 'truth' as it needs to be translated in a painting. Often, shadows, light and depth are lost and can only be recreated with a good knowledge of how things truly are—the human eye is the ultimate judge.

"As is often the case with my work, several negatives need to be projected for one piece (she often cuts an object out of one photo and adds it to another)

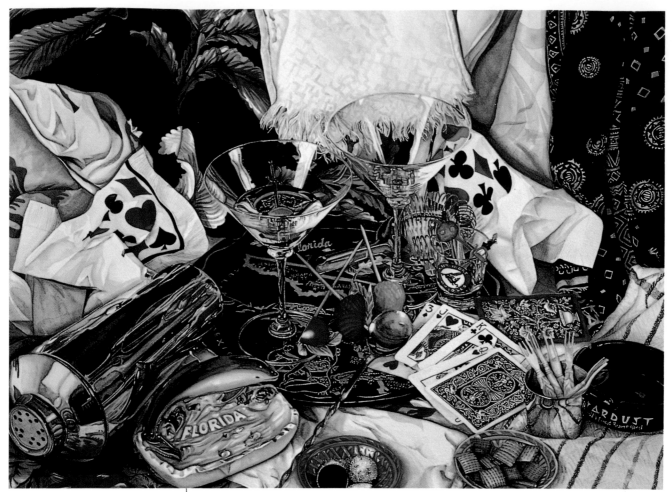

4 ▲ *She develops several different blacks to distinguish the dark objects—blue-black in the cloth on the left, purple-black on the tray, and green-black in the cloth on the right. Even though each object has been painted separately, you can see that the total painting has a look of unity, because each object contains reflected light and color from the objects next to it.*

LIFE OF LEISURE II
Jennifer Lewis-Takahashi,
21½″ × 28″
Collection of Tony Oswald

and I need to adjust placement and scale to make sure they appear to be part of a consistent setup."

Working One Section at a Time

Unlike most painters, Lewis-Takahashi completes one small section of the painting at a time. She starts with the focal point, often the most difficult object in the composition. As she paints, she refers to the original color photo. She works from light to dark in the area, until the section is complete. Then she moves on to the next, moving out from the "heart" of the painting.

She says, "I try to vary the type of work I do in any one sitting so as not to go crazy, perhaps working on fine-detailed areas for part of the time and then filling in the large washes of shadow and color needed for a large background area.

"I pre-think each area. Every day before I go to work, my mind thinks of what I have to do to the painting that day and goes through the steps. There are those moments of happy accidents despite all the planning."

When the total image is done, she goes back to check for depth and continuity. She may add a few final glazes to adjust color or value. Then she makes final adjustments to the composition by trimming the edges of the paper.

◄ Detail
In this close-up you can see the artist's painstaking attention to detail. Look, for instance, at the drop of water on the olive. She convinces us of the reflective nature of objects with careful attention to highlight and shadow on each surface as well as the patterns of reflected images.

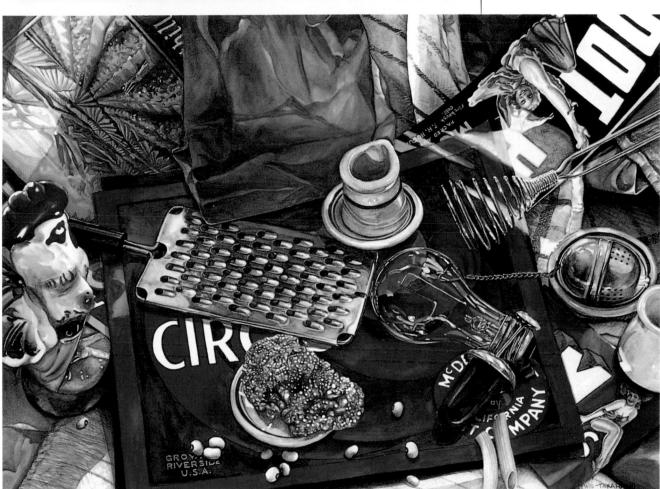

The Still Life Challenge
A complex still-life needs objects that are similar enough to work together visually, but different enough that the final image will be intriguing.

KITCHEN COLORS I
Jennifer Lewis-Takahashi,
28″×37″
Collection of Nancy and Jake
Jacobson

Carol Surface Shows You How To . . .

PAINT WITHOUT A SUBJECT

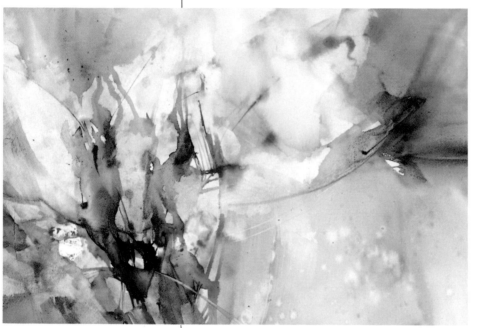

1 ▲ *Surface began this painting with no subject in mind. She poured Permanent Rose, French Ultramarine Blue and Burnt Sienna onto wet paper. Then she brushed it away, scraped it with a credit card and lifted it with toilet paper until it began to take on an energy that she liked.*

With most paintings the artist has a subject to direct the process. What provides the direction and momentum when there is no subject?

For Carol Surface the painting is driven by the movement of the paint itself and the challenge of design. She says, "The whole idea is reacting to the paper and the paint and the shapes you make with them."

Surface starts with color and shape, setting one or two compositional goals before she begins. Then she starts to pour color onto her paper and she lets the paint itself lead to each new step of the painting.

She varies her palette from painting to painting, trying not to keep reaching for the same few colors over and over. She says, "It really does come down to 'I feel red today' or 'I feel blue today.' Sometimes I mix colors to pour and then use totally different colors. To challenge myself, I might choose unusual colors, and I don't know how they'll go together."

Mastering the Elements of Design

Mastery of design is essential in nonobjective painting. Surface says that the principles and elements of design must be studied and practiced until they become second nature. This is best achieved by tackling each principle and element separately, painting studies of shape, value, color, line, texture and so forth. She promises if you are diligent in your efforts to practice these concepts, they will eventually emerge unconsciously in your paintings in a solid coordination of form and space.

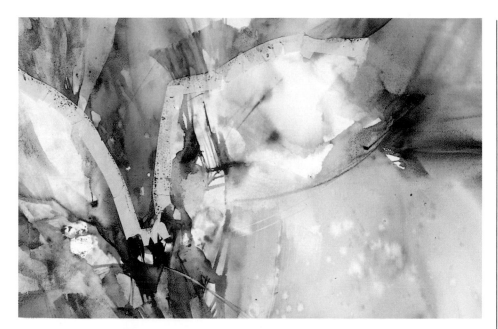

2 ◄ *Surface says she saw a vague suggestion of butterfly wings in the pigment and decided to take that further. With masking tape she marked off the area that would be the lighter wings and added more color above.*

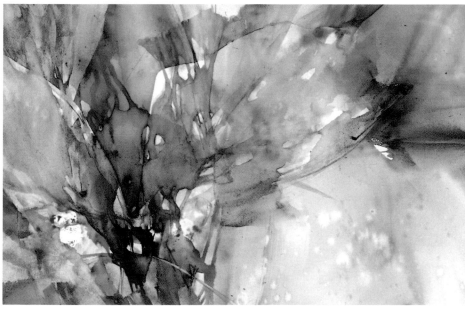

3 ◄ *She began to intensify the rest of the painting working wet-into-wet with lots of paint and not much water. Painting on Winsor & Newton paper with heavy sizing, she was able to add more washes and lift color off where it was too heavy.*

Five Things to Look for in Shapes

The design element that Surface is most concerned with is shape. Here is what she looks for in shapes:

1. *Variation.* Shapes should not be too even with their neighbor or flow too much in the same direction.
2. *Energy.* The shapes should be exciting by themselves.
3. *Deliberateness.* They should never look accidental or ambiguous.
4. *Continuity.* The shapes must look like they belong in the same painting.
5. *No points or sharp angles.* Unless you want the eye to go in a particular direction, these should be avoided.

Surface does include some recognizable imagery in her paintings, but she says the more experience she has, the freer she feels to let the shapes speak for themselves rather than describing or suggesting literal images.

4 ▶ *Surface used the technique of painting over wet media acetate to try out an intense yellow in the left wing shape. She didn't like the effect. Since she was not painting directly on the paper, she was able to simply remove the acetate.*

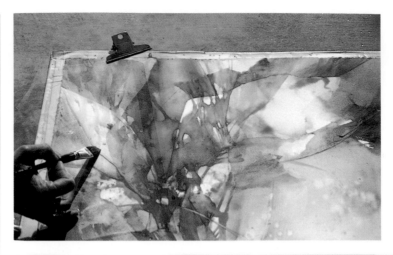

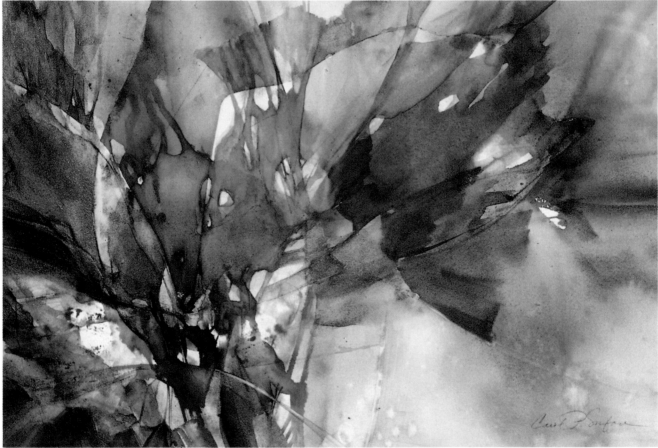

5 ▲ *When she finally had the colors as strong as she wanted them, she tested the finished painting by placing an L-shaped half mat over each quadrant. When she looks at the piece one-fourth at a time, she says the "eye stoppers" or design flaws become immediately apparent.*

WIND WEAVER
Carol Surface, 15″ × 22″
Collection of Mr. and Mrs. Ron Burman

Using Dominance as a Design Tool

Another important design tool she uses is dominance. She explains, "I think of it as the word 'mostly' and ask: Are the shapes mostly angular or curvilinear? Mostly hard or mostly soft? Is the painting mostly warm or mostly cool? If it waivers between the two, I push it toward one. When I study a painting in progress, I ask myself, 'What is it about? What kind of feeling does it have? How can I use the tools of design to carry that feeling through the painting's resolution?' "

She tests the design as she paints by placing a half mat over each quadrant. Each section of the painting must have a pleasing design that holds together.

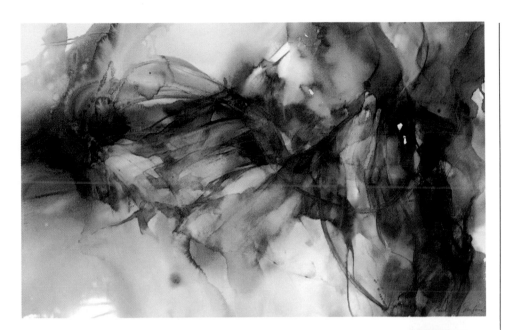

Some Common Mistakes

What are common flaws in the abstract paintings that don't work? Carol Surface lists them:

1. *No darks.* Beginners are generally afraid of the dark. You have to have strong values to give an abstract painting power.

2. *Sloppy strokes.* The strokes just kind of end out in the middle of nowhere as if the artist didn't bother to complete them.

3. *Over-brushed surface.* Don't brush the painting to death. Put on your paint and leave it there.

4. *Lack of conviction.* This especially shows up in not using enough paint when you put the darks on. Be bold. That bravery will make you look a lot more experienced than you may be.

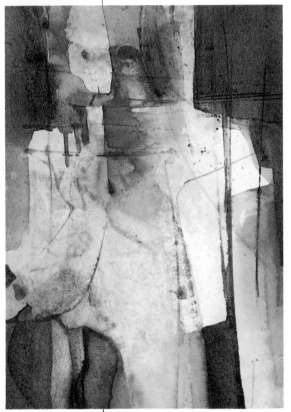

Sharon Hults Shows You How To...

PAINT A FAMILIAR LANDSCAPE WITH FRESHNESS

Reference Photos

Hults, who frequently paints the mountains near her Colorado home, is constantly looking for ways to make the landscape look different. Here she finds an interesting tree shape to add to the mountain background.

1 ▶ *After masking out the areas of the mountain and the foreground that she wants to remain white, she begins with a wash over the most distant part of the landscape.*

2 ◂ *She adds numerous layers of washes, salting and spraying each to create the organic texture that characterizes her mountain scenes.*

3 ▾ *When the background is in place, she removes the mask and completes the foreground. The finished painting is a fresh, luminous depiction of a mountain scene.*

LONG'S PEAK II
Sharon Hults, 22" × 30"

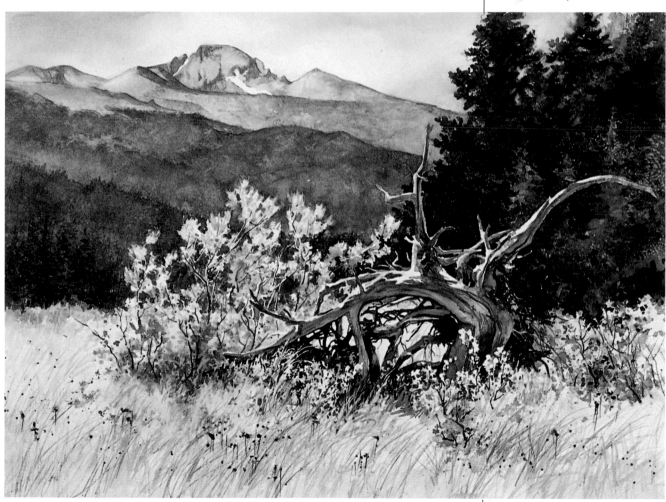

Robert Reynolds Shows You How To . . .

INTERPRET A SCENE IN A NEW WAY

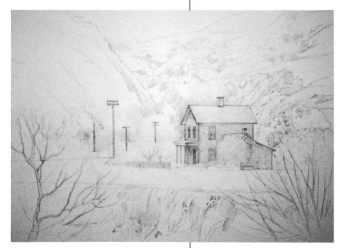

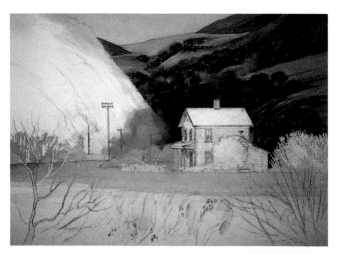

Masking
Reynolds begins by masking out the house and other details that will remain light.

1 ▲ *He starts painting the area of greatest spatial depth, making the background fairly dark to provide dramatic contrast for the white house.*

2 ▶ *He completes one section at a time, constantly looking to see that the colors and values are balanced throughout the entire composition.*

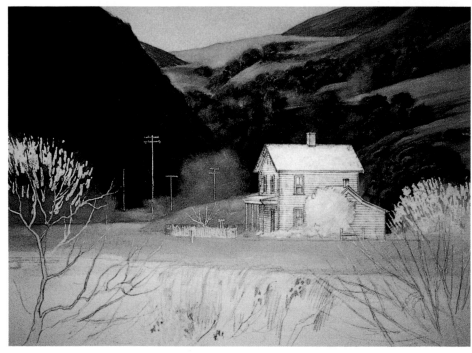

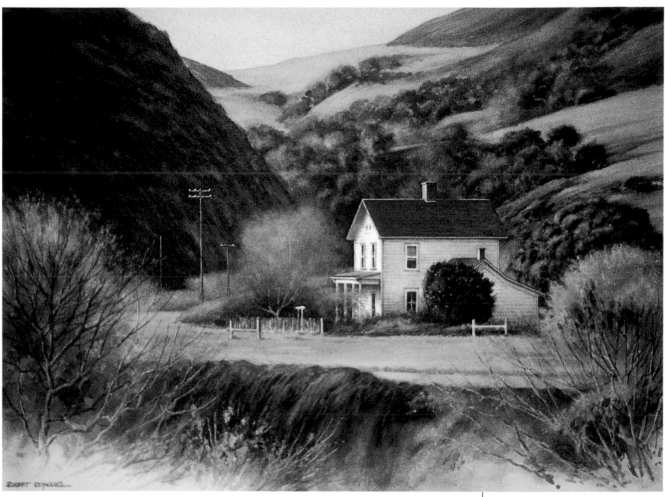

3 ▲ *In finishing, he removes the mask and completes the house and foreground.*

CURTI'S PLACE I
Robert Reynolds, 21″ × 29″

Another Look at the Subject
Reynolds points out that the same subject changes with variations in weather and lighting. He says, ''I have painted various views of this house near the small town of Cambria. Each season the area changes and has a completely different look and challenges more artistic interpretations.''

CURTI'S PLACE II
Robert Reynolds, 22″ × 30″

In the Mood

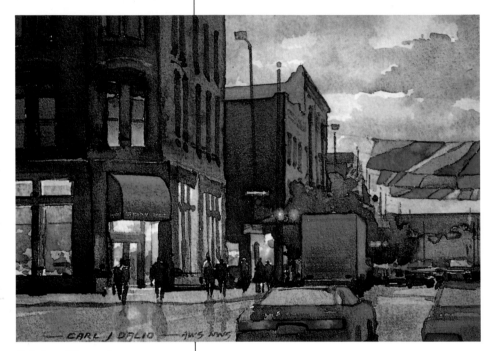

Paint an Atmosphere
Looking at this painting we know that it is a dark, rainy day. Dalio convinces us of the weather not just with the dramatic clouds in the sky, but also the reflections on the wet streets and the general coolness of color in most of the painting.

LARIMER SQUARE
Carl Dalio, 7″ × 9″
Collection of The Taos Gallery

TIPS FROM THE PROS
- Decide on the mood at the beginning and make every decision after that to enhance the mood.
- One of the most powerful tools we have for creating mood is light.

Professionals know that interesting color can happen by accident and so can wonderful shapes, but mood or atmosphere in a watercolor painting rarely happens by chance. Experienced artists decide on the mood at the beginning and make every decision after that to enhance the mood.

What do I mean by mood? I am talking about a strong emotional impact—how a painting makes you feel. Yes, the painting is well designed and brilliantly rendered, but does it go beyond the eye and the mind of the viewer? Does it touch something inside? It is a master painter who can make us want to walk through that landscape, take a bite out of that apple, or speak with that model.

Creating a Mood With Light

One of the most powerful tools we have for creating mood is light. Look at the effect of light in your life. If you want a romantic mood, you turn off the overhead lights and light some candles. If you want a sharp, businesslike mood, you switch on the fluorescents. When you want to feel safe, you turn on the lights; when you want to feel mysterious, you turn them off.

Nature does the same thing for us by changing the position of the sun. At noon, when the sun is straight overhead, things are sharp and bright. Early in the morning and late in the afternoon, things appear softer, more lyrical. The warm light from a violet sunset casts a magical feel over everything. The dim light of a foggy day makes things harder to see; you turn inward, and feel reflective.

Simply by observing and recreating the light of your environment, you can go far toward putting mood into your paintings. Douglas Osa says, "I don't

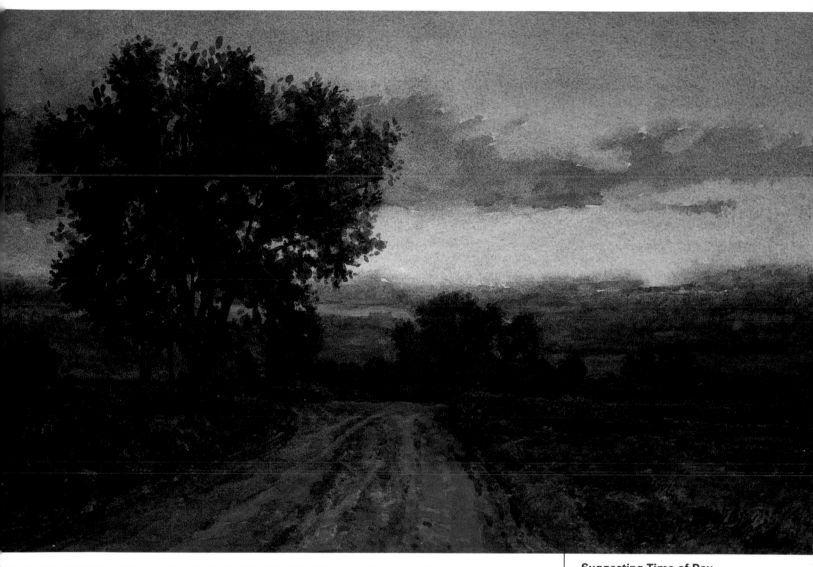

Suggesting Time of Day
Even without reading the titles, you can tell what time of day these scenes were painted. With her many layers of warm glazes, Anderson makes us feel the early morning sun shining through the fog. Osa creates evening with a darker palette and the suggestion of sunset color on the horizon and reflected in the clouds.

SUNSET, EVENINGSTAR ROAD
Douglas Osa, 14" × 21"

GOOD MORNING
Catherine Anderson, 29" × 36"

Unusual Lighting
Long shadows add intensity to an otherwise typical farm scene.

CONNECTICUT FARM
Leonard Mizerek, 18″ × 22″

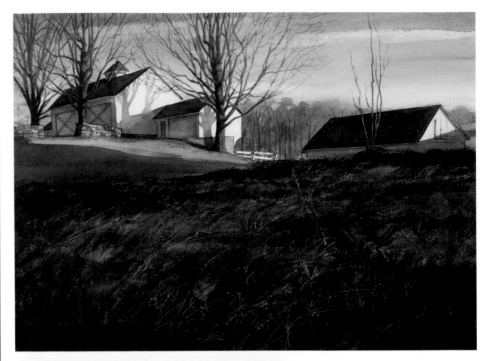

The Drama of Light and Shadow
What could have been an unexceptional painting of a wagon on a hill becomes dramatic because of the wagon's placement half in bright sunlight and half in dark shadow.

HILLSIDE LIGHT
Robert Reynolds, 19″ × 28″
Courtesy of New Masters
Gallery, Carmel, CA

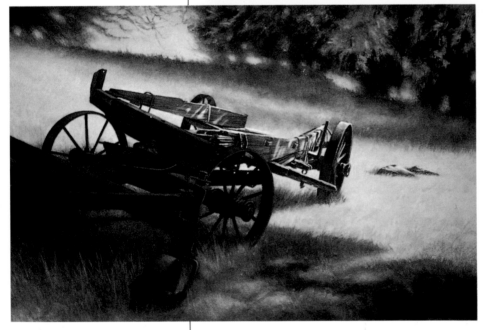

think you can separate the light and weather from the forms; they are integral. The sky establishes the entire mood of the painting. I see the weather and the light and the landscape as all one; you can't subtract one without sacrificing the whole thing."

Using a Range of Values

We show light primarily with our use of value. The strongest light, high noon, shows up in strong value contrast—brilliant highlights and dark shadows, the full value range from white to black. Softer light results in a narrower value range. Higher key (lighter) paintings will look happier; lower key (darker) paintings will look more thoughtful, somber, even forbidding, depending on how dark they are.

One of my favorite techniques is using backlighting. By making the background light and the figures dark, I add an immediate dramatic impact to my painting.

With watercolor it's especially important to decide on the mood and value range from the beginning because once you put those dark darks into the painting, you can never get back to pure lights.

TIPS FROM THE PROS
- By observing and recreating the light of your environment, you can go far toward putting mood into your paintings.
- Higher key (lighter) paintings will look happier; lower key (darker) paintings will look more thoughtful, even somber.
- Backlighting—which makes the background light and figures dark—adds immediate and dramatic impact to your painting.

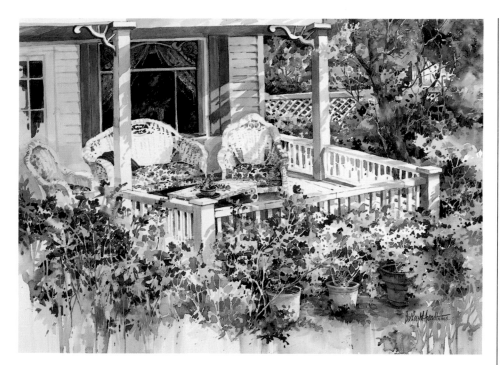

High-Key Painting
This painting conveys a gentle, peaceful feeling partly because of the cozy subject matter, but also because of the high-key treatment. The large expanse of white reinforces the mood.

PRESCOTT PORCH
Mary DeLoyht-Arendt, 22″×30″
Courtesy of O'Briens Art Emporium, Scottsdale, AZ

Create Excitement With Sharp Angles
The sharp, angular nature of the shapes in this composition create energy and excitement.

TERPSICHORE
Carol Surface, 30″×22″

What Else Contributes to Mood?

Color is another important contributor to mood. The effects of color temperature are straightforward; a painting in which warm colors are dominant will actually feel warmer, and vice versa.

Color Intensity

Intensity of color should also be considered. Strong, pure colors tend to look bold and energetic. Muted or grayed colors support a softer mood.

Brushstrokes

The brushstroke is also very important. Big, bold strokes give the painting an aggressive feel. Softer, lighter strokes are the opposite. Linear, geometric strokes and shapes look mechanical, more intellectual than curving strokes. Sharp angles can appear angry, hostile.

Hard and Soft Edges

Be aware of edges. Using only hard edges gives the image a crisp, definite—at times, harsh—look. The soft edges of painting wet-into-wet look less certain, at times even mysterious.

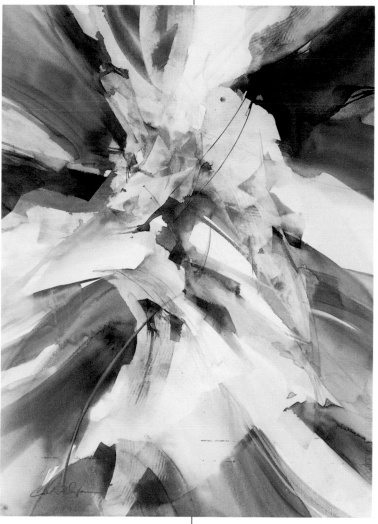

A Joyful Mood

Penny Stewart's whimsical use of color and shape gives the paintings a joyous feel regardless of the subject matter.

GOIN' TO TOWN
Penny Stewart, 22" × 30"

Soft Edges Set the Mood

When painted with bright colors and sharp edges, daisies have a perky feel. Wiegardt has given this painting a more contemplative mood by keeping the edges soft and using less brilliant colors.

DAISIES
Eric Wiegardt, 14" × 18"
Collection of Gerd Tuchscherer

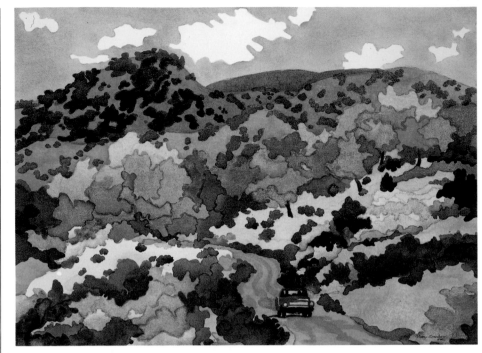

Point of View

The final element that affects mood is point of view. Where is the viewer standing while looking at the painting?

If you paint the scene from a distance, it is much less intimate than the same scene shown close up. Looking down or looking up at a subject will subtly alter the way the viewer feels about the subject. Painting a group of people from over the shoulder of one of the group will make the viewer feel like an eavesdropper.

There are so many different elements that go into determining the mood of a painting that the artist must decide on the mood from the beginning. Then throughout the course of the painting, each element that you introduce can contribute to the final effect you want to create.

TIPS FROM THE PROS

- Fascinate with suggestion—if you can get the viewer to complete the statement, even without his knowing it, the painting becomes more real to him.
- Using only hard edges gives the image a crisp, definite—at times, harsh—look. Soft wet-into-wet edges look less certain, even mysterious.
- Light is expressed in relationships. The value of the highlight is often not as important as the values that surround it.

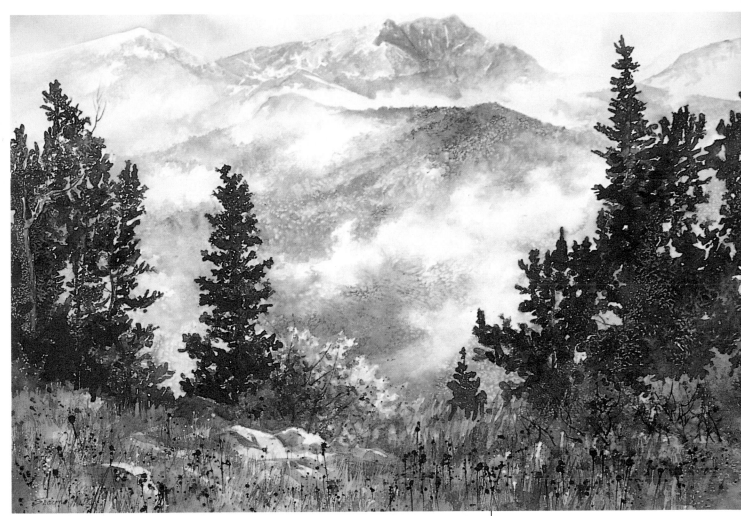

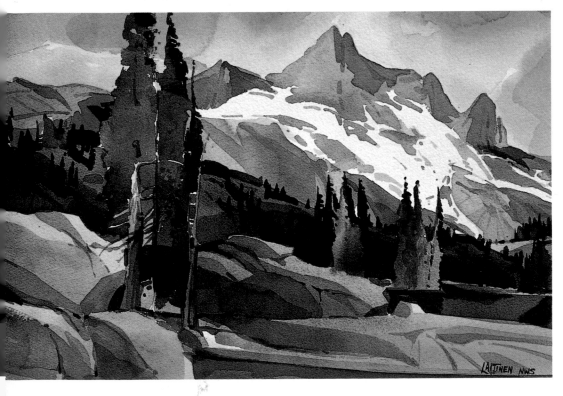

Two Different Mountain Moods

These are two mountain paintings, but notice the very different feeling each has because of the painting techniques used. With the delicate detail of the flowers, the lacy painting of the trees, and the softness of paint in the fog areas, Hults's mountain scene seems soft and intimate. In contrast, Laitinen painted his mountain with bold shapes of dense color. The view appears harder and the mountain more distant.

WINTER FOG
Sharon Hults, 21" × 28"

GRAY GRANITE, BLUE SHADOWS
Dale Laitinen, 15" × 22"

Robert Reynolds Shows You How To...

CAPTURE THE GLOW OF LIGHT

Pencil Drawing

Reynolds begins with a pencil drawing on his watercolor paper. He says the composition is vital because "a representational painting is only as successful as its abstract design."

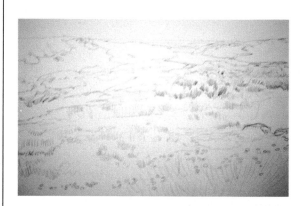

R obert Reynolds's paintings glow. When looking at his brilliant sunsets, the viewer feels the vibration of the changing light of day passing into night. There is a mood or life to his paintings that goes far beyond a factual description of the subject. To get that mood, he starts with the light.

Reynolds says, "I have been obsessed with the light lately, especially as it reflects off bodies of water. It's not what you do where the light is hitting, but what you do around the light—the forms and colors as they approach the light and the slow gradations to the darks. I think that's what makes the glow."

Reynolds thinks about composition and values from the beginning, knowing that light is expressed in relationships. The value of the highlight itself is often not as important as the values that surround it.

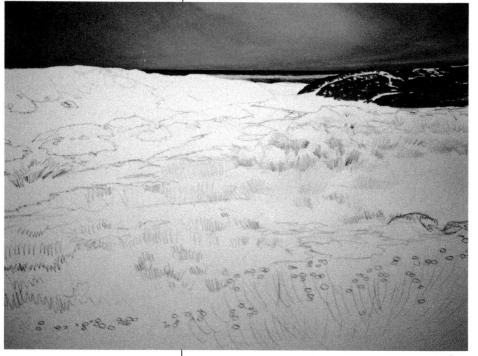

1 ▲ *He begins by painting in the sky, leaving a lighter area to indicate the placement of the sun. Much of the emotional impact of his paintings is due to the careful planning of the light.*

Reynolds says, "It is generally my practice to place the lightest and darkest values on my paper as soon as possible. This enables me to concentrate on intermediate values without losing sight of the range of values I had originally perceived."

Placing the Sun and Horizon

Reynolds has two main considerations: where to place the horizon line and where to place the sun. Placing the horizon line determines whether the land

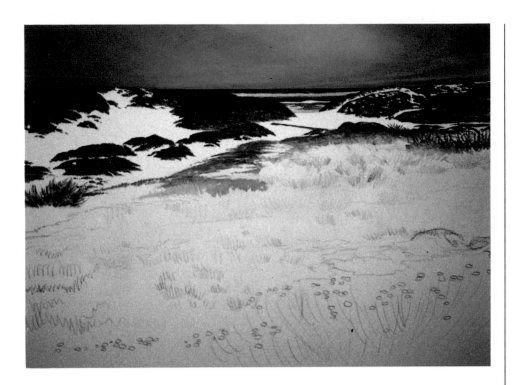

2 ◄ *Reynolds paints from top to bottom. He adjusts colors and values as he goes along, intensifying colors with additional glazes and lightening areas with a dampened facial tissue or sponge.*

or the sky will be the largest shape in his piece. It also affects the mood, giving the viewer the sense of either looking down at the ground or up at the sky.

"With glazing and lifting, it takes me hours to do a sky that looks like it was done in five minutes," says Reynolds. "Sometimes it doesn't happen in nature the way you want it. It may be a blue sky, and I don't want that postcard blue, so I make it violet. The color of the sky affects all the colors because all the objects reflect the sky."

Placing the sun will determine not only the relationship of values throughout the composition, but also the direction of all the highlights and shadows. He says it's all right to take "artistic license" and make adjustments that will improve the design or mood of the painting as long as the overall sense of the light remains believable.

Painting on Location

Even though he does most of his finished painting in the studio, Reynolds says it's imperative to spend time on location. He explains, "Nature changes constantly. Each time I return to the outdoors, I hope to be surprised and inspired, and I am seldom disappointed."

The work that he does on site—observing, making value and color studies and taking reference photos—enables him to paint convincingly in the studio. It is a vital part of each painting.

"Usually I sketch in ink rather than pencil," Reynolds says, "mostly because it doesn't smudge, and I'm able to establish the lights and darks rapidly. Although the medium is unforgiving, its directness sharpens my awareness and encourages me to think in terms of design as I sketch. I use fountain pens, ballpoints, felt tips and even sticks dipped in ink—anything that gives me an expressive line.

3 ▸ *The unusual sky color adds to the mood of the piece. The strong colors in the foreground and the strong patches of white keep the painting from being too somber.*

PACIFIC COAST REDS
Robert Reynolds, 21″ × 29″

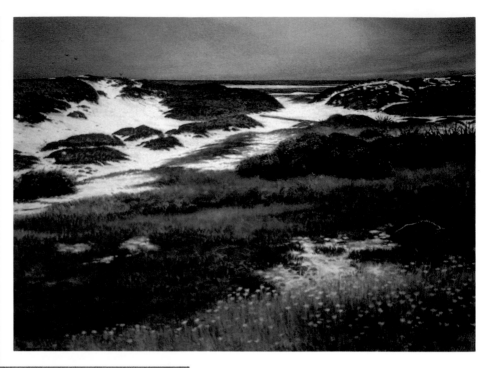

Capturing the Character of Light
One reason Reynolds likes to paint at sunset is because the character of the light changes. Notice how he uses the warm light to enrich the color of his entire painting.

BACK BAY SUNSET
Robert Reynolds, 27½″ × 37″

"I usually make color notes and use my camera to record details when on location. From these aids, I can graphically piece together my own version of reality. I do not try to duplicate my subject; however, I do feel an obligation to capture a sense of place of the particular location."

From the initial choice of subject throughout the painting process, Reynolds continues to be aware of the mood he is trying to create. And even when he thinks the piece might be complete, he continues to assess its impact.

"I allow the painting to stay on the board for some time," he says "and occasionally walk past it in the studio and try to view it at unguarded moments. These moments are very important, because setting aside the technical aspects of the painting, the painting must live or die on its emotional and aesthetic attainments."

Eric Wiegardt Shows You How To...

PAINT THE FEELING OF WEATHER

When the fog rolls into the Pacific Northwest, the whole world changes. Light gets softer; images get hazier and these changes are reflected in the way people feel. This climate has a profound effect on Eric Wiegardt's art, whether it is painting soft, wet images of an overcast day, or creating sharp, bright images as a contrast to the weather.

Most of Wiegardt's paintings are simple, even minimalistic compositions where the mood or atmosphere itself is often the subject. "I have to have a sense of the mood before I begin," he says. "I have to be clear in the emotion and the attitude I want to project.

"It's critically important that you're emotionally connected to your subject. It's necessary that you've seen it, touched it, smelled it—then it becomes yours. Working from someone else's photos won't go far."

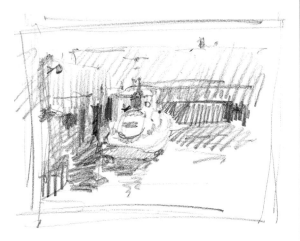

Preliminary Study
Wiegardt works out basic compositional and value problems in a preliminary graphite sketch.

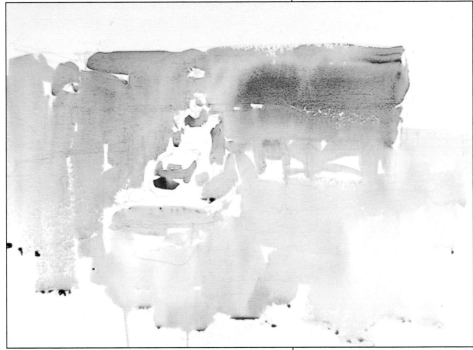

1 ▲ *Over a light gestural drawing he lays in the big mid-tone shapes with a 2-inch brush.*

An Intuitive Approach to Painting

Clarity regarding his subject is essential because he works fast and intuitively. He explains, "I don't have any preconceived formulas. I like to paint all at once, take the plunge. Then I do whatever it takes to get the job done of saying what I want to say.

2 ▸ *Since this is to be a hazy, overcast day, he wants many soft edges. He achieves that by working rapidly on the wet paper and allowing masses of color to run together.*

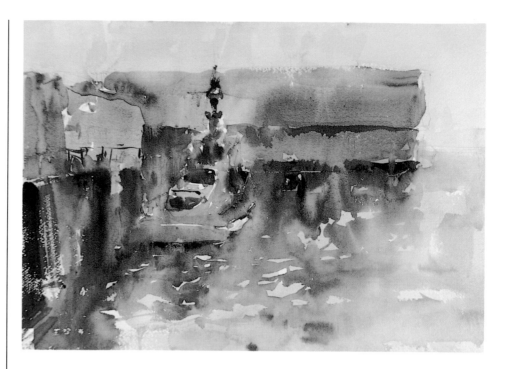

"I'm real physical with my paper. I use whatever colors I want and then get in there with my bristle brush, lifting and moving color, softening edges, scrubbing. Watercolor to me is not a gentle medium where you lay in timid washes and let them dry. I get right in there and wear my brushes out."

Wiegardt prefers to work on damp paper that's in transition from wet to dry, when the sheen is off. "I do not wet the whole paper first," he says, "but capitalize on my initial damp washes with successive pigment applications. This allows for a spontaneous edge quality unique to watercolor. Since timing is so critical, I find I must judge quickly and rely on my intuitive impulses."

Simplifying Shapes and Values

One thing that allows quick decision making is preplanning the values and shapes of the composition. He says, "Like most artists I like to take complex shapes and simplify them into a value pattern. My reference material is usually a thumbnail sketch of the values I see on location—some descriptions in words and some photos."

It is important to plan and paint the entire painting. He says that many of his students do an incredible job when it comes to rendering the "area of dominance" (the center of interest), but they either ignore or dismiss the large shape of the foreground. Even if you put just a few carefully considered strokes in the foreground area, it is necessary to complete that part of the painting as well.

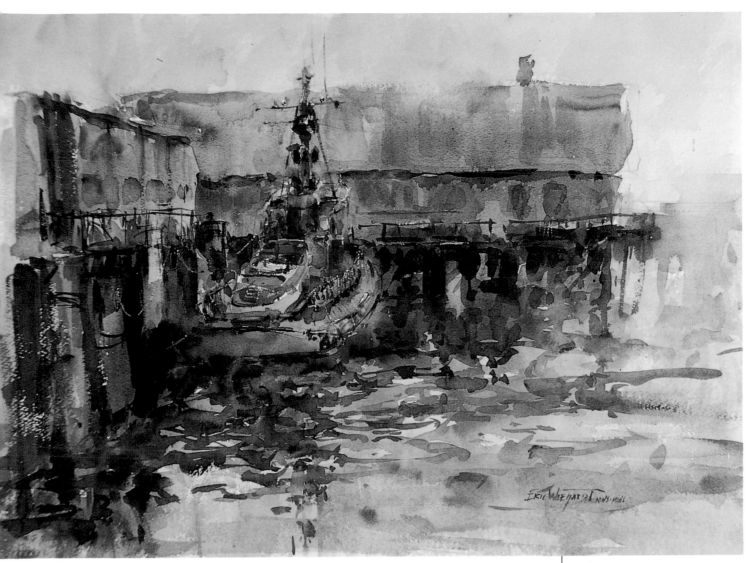

3 ▲ *Once the paper is dry, he adds just enough detail to make the subject recognizable, then scratches out white highlights with a razor blade.*

PILOT BOAT
Eric Wiegardt, 16″×22″

The Power of Suggestion

He warns not to be a slave to the reality either of photographs or location. Wiegardt is constantly trying to simplify, reducing the subject to large shapes and eliminating all but the most important details.

He explains, "I try not to be influenced by what is expected. The bottom line is whether it says what I've got to say. Then I've gone far enough. If your strokes are not adding, they are taking away.

"I have a real fascination with suggestion, although it takes more work on my part than giving the viewer all the information. If I can get the viewer to complete the statement, even without his knowing it, it becomes more real to him. The painting will last more years because the viewer is bringing himself to it."

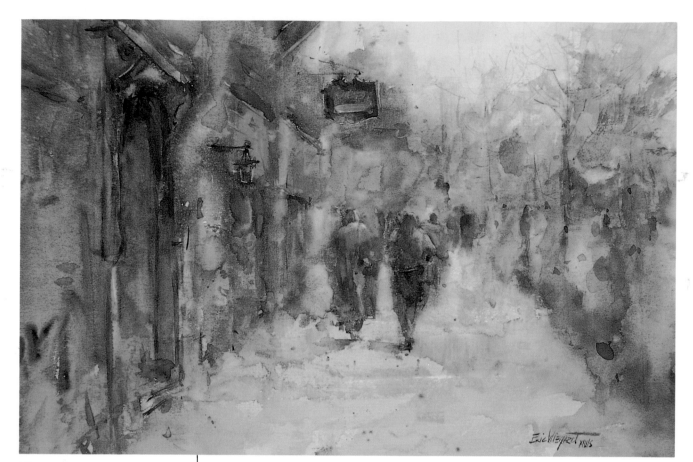

Viewer Participation
Wiegardt suggests activity with this vibrant surface texture of unconnected strokes, spots of color and calligraphic lines. He says he likes to suggest rather than describe scenes so that the viewer can participate in the painting.

UNIVERSITY DISTRICT
Eric Wiegardt, 22″ × 30″
Collection of Lester and Gail Marty

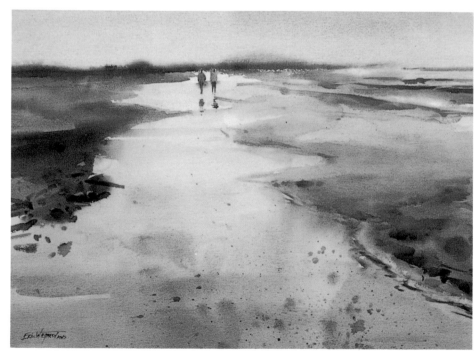

A Solitary Mood
By placing the two small figures in the midst of so much open space the artist creates the feeling of solitude.

TWILIGHT
Eric Wiegardt, 22″ × 30″
Collection of Ernie and Marilyn Ford

HOW TO MAKE YOUR WATERCOLORS LOOK PROFESSIONAL

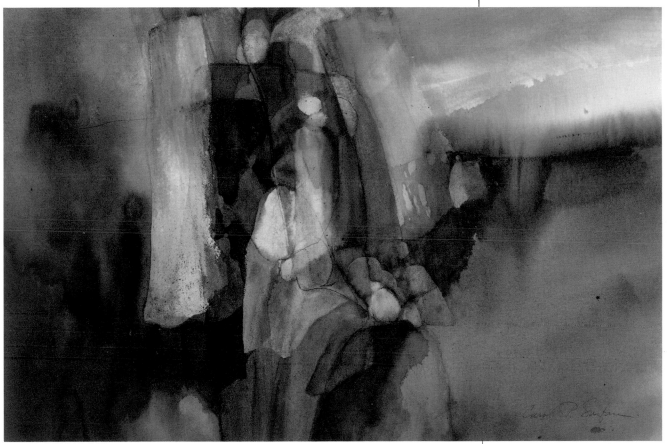

THE SALVATION
Carol Surface, 15″×22″
Collection of Ms. Terylann Knee

TIP 1
Be bold with your strokes. Even when you don't know what you're doing, paint as if you do.

TIP 2
Use the best materials that you can afford.

TIP 3
Use plenty of color. Load the brush with color. Never be stingy with your paint.

TIP 4
Draw. Use a sketchbook constantly.

WINDJAMMER DAYS
Leonard Mizerek, 11" × 20"

TIP 5
Take the time to plan your paintings.

TIP 6
Think about the mood that you want to establish.

TIP 7
Know where the light is coming from.

TIP 8
Look for negative shapes and structure.

TIP 9
Work toward a full range of value, very light to very dark with a full range of grays in between. And don't be afraid of the darks.

TIP 10
Don't be infatuated with tricks and gimmicks. A little bit goes a long way.

TIP 11
Do a lot of looking.

TIP 12
Experiment. And expect a great big pile of used paper. Don't be afraid of wasting paper. You learn a lot more by ruining a painting than by trying not to make any mistakes.

TIP 13
Let the original statement stand. Don't rework.

TIP 14
Avoid unnecessary detail. Focus on the big picture. Decide what the story is you're trying to tell.

SUNSET, SHAWNEE MISSION
PARK
Douglas Osa, 23″ × 35″

TIP 15
Never forget your center of interest.

TIP 16
Paint with your whole body.

TIP 17
Practice. Practice. Practice.

TIP 18
Make the failures work for you. Figure out what you did wrong and learn from it.

TIP 19
Don't be in a hurry. You don't have to learn everything today or tomorrow. Start with simple subjects, then progress to more complicated paintings.

TIP 20
Don't be afraid to ask for help.

TIP 21
Join a critique group.

TIP 22
Have confidence in yourself. Be prepared to go through some of the low times, and when the high times come, paint like crazy.

PERMISSIONS

Bougainvillea (collection of Michele Scott), *Harbor, For Elissa, Shade* (collection of Curt Wilson), *Sentient Beings, Good Morning, Oakville Grocery* copyright by Catherine Anderson. Used by permission.

Heirloom, Along the Bank, Summer House, A Cozy Abode for Birds (courtesy of O'Briens Art Emporium, Scottsdale, AZ), *Prescott Porch* (courtesy of O'Briens Art Emporium) copyright by Mary De-Loyht-Arendt. Used by permission.

The Angles of the Argo, Florida Shrimp Dock, Dry Dock in Hawaii, Breakfast in Vail, The Constitution copyright by William H. Condit. Used by permission.

Afternoon Shadows—Fifth Avenue (collection of the artist), *Afternoon Light—Snake River Valley* (collection of Mr. & Mrs. G. L. Martyn), *Colorado Front Range* (collection of the artist), *The Flower Garden—Northern New Mexico* (collection of the artist), *Still Life in Green* (collection of Mr. & Mrs. J. E. Norris), *Palm Grove* (collection of Leroy Springs Company), *Flatiron* (collection of Eric C. Dalio), *Larimer Square* (collection of the Taos Gallery, Taos, NM) copyright by Carl. J. Dalio. Used by permission.

Tea Party, Midsummer's Night Scream (Private collection), *Ralph's Corner I* (courtesy of the Handcrafter Gallery & Studio, Telford, PA), *Ralph's Corner II* (collection of Mr. & Mrs. Robert Fortier), *Zinnias* (collection of Mr. & Mrs. Rudolph Forst), *Grim Reaper* (courtesy of De Virgilis—Fine Art, North Wales, PA) copyright by Kass Morin Freeman. Used by permission.

Autumn Symphony, Wilson Peak, Warmed by the Sun, Long's Peak I, Afternoon Light, Long's Peak II, Winter Fog copyright by Sharon Hults. Used by permission.

Apples & Pears, Bag of Fruit, Conversation in Soho, Invitation to Dance, Realtors on Friday copyright by Carole Katchen. Used by permission.

River Town (collection of Don & Alice Hamblin), *Low Tide, Light Catcher, November Light Grand Canyon* (collection of the Dolese Company), *Sierra Snow, Gray Granite, Blue Shadows* copyright by Dale Laitinen. Used by permission.

Beach Stroll, Low Tide, Catch of the Day, Paper Cutouts, Sunday Funnies, Yellow Bleachers, Morning Light, Market Day copyright by Martha Mans. Used by permission.

Schooner Days, Hendrick's Head Light (and study), *Annapolis Harbor, Chesapeake Skipjack E. C. Collier* (and study), *Tenant's Harbor, Connecticut Farm, Windjammer Days* copyright by Leonard Mizerek. Used by permission.

Sky Pond (courtesy of Hensley Gallery Southwest, Taos, NM), *Tryst Falls, Building Storm, Hay Bales at Sunset, Union Street, Sunset, Eveningstar Rd., Sunset, Shawnee Mission Park* copyright by Douglas L. Osa. Used by permission.

Estuary (courtesy of New Masters Gallery, Carmel, CA), *Morning Reflections* (collection of Dr. Donald Rink), *Back Bay Light* (collection of Dr. Arthur J. Silverstein), *Still Waters/Summer Blossoms* (collection of Dr. Donald Rink), *Curti's Place I, Curti's Place II, Pacific Coast Reds* (courtesy of New Masters Gallery, Carmel, CA), *Hillside Light* (courtesy of New Masters Gallery, Carmel, CA), *Back Bay Sunset, Moonstone Bay* (collection of Dr. & Mrs. Robert Fishburn) copyright by Robert Reynolds. Used by permission.

The Third Day (collection of Judy & Mel Grimes), *Haiku #21* (collection of the artist), *Water Light #33* (collection of the artist), *Feather Light #9* (collection of Aryna Swope), *Haiku #3, Haiku #17* (collection of Janie C. Shen), *Haiku #10, Fingers* (collection of Robert Dunlap), *Feather Light #12* (collection of Joe Harch) copyright by Linda L. Stevens. Used by permission.

Iglesia en Pilar, Hondo Hacienda, Primavera en Cordova, Vista de Val-

dez (collection of Celine Krueger), *Goin' to Town, Lady in the Garden* copyright by Penelope Stewart. Used by permission.

Day Break (collection of Susan Henry), *Spirit Shift, Nature's Harvest, Passing Glimpse* (collection of Mr. & Mrs. Wally Barrows), *Wind Weaver* (collection of Mr. & Mrs. Ron Burman), *Private Dancer* (collection of Ms. Terylann Knee), *Life Journeys* (collection of Max & Naida Shaw-Kay), *Terpsichore, The Salvation* (collection of Ms. Terylann Knee), *Sentimental Journey* (collection of Ms. Terylann Knee) copyright by Carol P. Surface. Used by permission.

Music & Mirrors I, Straw into Gold II (collection of Dan Ho), *Buttons, Beads & Boxes I, The Overseer I, Life of Leisure II* (collection of Tony Oswald), *Kitchen Colors I* (collection of Nancy & Jake Jacobson), *Buttons, Beads & Boxes II* copyright by Jennifer Lewis-Takahashi. Used by permission.

Cosmos 3 (collection of Colleen Rinkel), *Seaside Promenade, Dinner* (collection of Lyle & Marilyn Jane), *Chinatown* (collection of Dennis & Doris Hudson), *Pilot Boat, Twilight* (collection of Ernie & Marilyn Ford), *University District* (collection of Lester & Gail Marty), *Daisies* (collection of Gerd Tuchscherer), *Man on Bicycle* (collection of Arlene Sparks), *Drydock* (collection of Denise Fuentes) copyright by Eric Wiegardt. Used by permission.

INDEX

More Great Books
for Beautiful Watercolors!

Paint Watercolors Filled with Life and Energy—Discover how to paint watercolors that vibrate with emotion! Using the "Westerman No-Fault Painting System," you'll learn how to overcome your fear of making mistakes by using your materials and brushstrokes to create powerfully expressive work. *#30619/$27.95/ 144 pages/275 color illus.*

Painting Watercolor Florals That Glow—Capture the beauty of flowers in transparent watercolor. Kunz provides six complete step-by-step demonstrations and dozens of examples to help make your florals absolutely radiant. *#30512/$27.99/144 pages/210 color illus.*

100 Keys to Great Watercolor Painting—Discover loads of tips for making your washes dry faster, correcting mistakes, creating soft glazes, loosening brushstrokes and more! *#30592/$16.95/64 pages/color throughout*

Creating Textures in Watercolor—It's almost magic! Discover how textures create depth, interest, dimension . . . and learn how to paint them. Johnson explains techniques for 83 examples—from grass and glass to tree bark and fur. *#30358/$27.95/144 pages/115 color illus.*

Fill Your Watercolors with Light and Color—"Pour" life and light into your paintings! Here, Roland Roycraft gives you dozens of step-by-step demonstrations of the techniques of masking and pouring. *#30221/ $28.99/144 pages/100 b&w, 250 color illus.*

The Watercolor Painter's Pocket Palette—Mix the right colors every time! This handy reference, packed with dozens of color mixes, takes the "error" out of "trial and error" watercolor mixing. *#30341/$16.95/64 pages/ 200 + color illus./spiral bound with spine*

Learn Watercolor the Edgar Whitney Way—Learn watercolor principles from a master! Let Whitney's words, gleaned from dozens of his workshops, and a compilation of his artwork show you the secrets of working in this beautiful medium. *#30555/$27.99/144 pages/130 color illus.*

Zoltan Szabo Watercolor Techniques—Learn to paint the beauty of an azalea bloom, the delicacy of a spider's web and more! You'll master the techniques of watercolor as Szabo takes you through the process from mixing paint to creating strong composition. *#30566/ $16.99/96 pages/100 color illus./paperback*

Jan Kunz Watercolor Techniques—Take a Jan Kunz workshop without leaving home! With 12 progressive projects, traceable drawings, and Kunz's expert instruction, you'll paint enchanting still lifes and evocative children's portraits in no time! *#30613/$16.99/96 pages/80 color, 60 b&w illus./paperback*

Webb on Watercolor—Discover how to put more expression in your painting style! With Frank Webb's unique teaching style, you'll learn how to see, to develop good habits of craft, and to stoke your enthusiasm for painting. *#30567/$22.95/160 pages*

Painting Watercolor Portraits That Glow—You'll learn how to paint lively, accurate, and brilliantly colorful portraits with in-depth instruction and detailed demonstrations from master artist, Jan Kunz. *#30103/$27.95/160 pages/200 color, 200 b&w illus.*

Watercolor: You Can Do It!—Had enough of trial and error? Then let this skilled teacher's wonderful step-by-step demonstrations show you techniques it might take years to discover on your own. *#08833/$29.95/176 pages/163 color, 155 b&w illus.*

Splash 3: Ideas & Inspirations—You'll explore new techniques and perfect your skills as you walk through a diverse showcase of outstanding watercolors. Plus, get an inside glimpse at each artist's source of inspiration! *#30611/$29.99/144 pages/136 color illus.*

Splash 2: Watercolor Breakthroughs—With over 150 gorgeous full-color reproductions, you'll see how 90 artists made their personal breakthroughs to excellence. Best of all—you can put their techniques to work for you! *#30460/$29.95/144 pages/150 + color illus.*

Splash 1—If you missed out the first time, this is your chance to draw inspiration from the beautiful showcase of contemporary watercolors that kicked off the Splash craze. Plus, you'll refine your skills by observing a wide range of styles and techniques in large, full-color detail. *#30278/$29.95/152 pages/160 color illus.*

Painting Buildings in Watercolor—Discover how to capture the grace and beauty of architecture with eight step-by-step demonstrations in this fully-illustrated guide. *#30562/$27.95/144 pages/200 color, 7 b&w illus.*

Basic Watercolor Techniques—You'll discover exactly how watercolor works and how to create the effects you desire with in-depth instruction from seven outstanding artists. *#30331/$16.95/128 pages/150 color illus./paperback*

Ron Ranson's Painting School: Watercolors—No matter what your skill level, you'll be able to dive right into the world of watercolors with the practical teaching approach of noted painter, Ron Ranson. *#30550/$19.95/128 pages/200 + color illus./paperback*

Painting Nature's Peaceful Places—Celebrate the splendor of nature as you discover the secrets of painting her most precious gifts. The three part art "course" found in this insightful guide shows you how! *#30518/ $27.95/144 pages/220 color illus.*

Painting Outdoor Scenes in Watercolor—Portray the beauty of outdoors in your watercolors! Here you'll learn how to paint the seasons, how to harness the power of light, and more! *#30474/$27.95/144 pages/290 color illus.*

How To Make Watercolor Work for You—You'll discover the expressive potential of watercolor using the secrets and inspiration of a master watercolorist, Frank Nofer! *#30322/ $27.95/144 pages/114 color, 11 b&w illus.*

The Watercolorist's Complete Guide to Color—You'll learn how to mix colors, choose color palettes, and use color to create light, shadow, distance, atmosphere, texture and more. *#30388/$27.95/144 pages/200 + color illus.*

The Wilcox Guide to the Best Watercolor Paints—This color-by-color, make-by-make comparison of the quality and reliability of over 2,000 paints will ensure you buy the best! *#30350/$24.95/285 pages/color throughout/ paperback*

Watercolor Tricks and Techniques—Learn 54 subtle tricks you can use to turn an ordinary painting into an extraordinary one! *#30440/ $21.95/144 pages/290 color illus.*

Watercolor Workbook—Improve your skills with 31 practical, inviting watercolor lessons on color, value, line, form and more! *#8841/ $22.99/140 illus./paperback*